BLOODBATH NATION

Also by Paul Auster

BLOODBATH NATION

PAUL AUSTER

Photographs by
SPENCER OSTRANDER

Grove Press

New York

Published simultaneously in Canada
Printed in the United States of America

First Grove Atlantic hardcover editon: January 2023

ISBN 978-0-8021-6045-4
eISBN 978-0-8021-6046-1

Library of Congress Cataloging-in-Publication data is available for
this title.

Grove Press
an imprint of Grove Atlantic
154 West 14th Street
New York, NY 10011

Distributed by Publishers Group West

groveatlantic.com

23 24 25 26 10 9 8 7 6 5 4 3 2 1

AUTHOR'S NOTE

The images that accompany the words of this book are photographs of silence. Over the course of two years, Spencer Ostrander made several long-distance trips around the country to take pictures of the sites of more than thirty mass shootings that have occurred in recent years. The pictures are notable for the absence of human figures in them and the fact that no gun or even the suggestion of a gun is anywhere in sight. They are portraits of buildings, often bleak, ugly buildings in undistinctive, neutral American landscapes, forgotten structures where horrendous massacres were carried out by men with rifles and guns, briefly capturing the country's attention and then fading into oblivion until Ostrander showed up with his camera and transformed them into gravestones of our collective grief.

BLOODBATH NATION

1

I have never owned a gun. Not a real gun, in any case, but for two or three years after emerging from diapers, I walked around with a six-shooter dangling from my hip. I was a Texan, even though I lived in the suburbs outside Newark, New Jersey, for back in the early fifties the Wild West was everywhere, and numberless legions of small American boys were proud owners of a cowboy hat and a cheap toy pistol tucked into an imitation leather holster. Occasionally, a roll of percussion caps would be inserted in front of the pistol's hammer to imitate the sound of a real bullet going off whenever we aimed, fired, and eliminated one more bad guy from the world. Most of the time, however, it was sufficient merely to pull the trigger and shout, *Bang, bang, you're dead!*

The source of these fantasies was television, a new phenomenon that began reaching large numbers of people precisely at the time of my birth (1947), and because my father happened to own an appliance store that peddled several brands of TVs, I have the distinction of being one of the first people anywhere in the world to have lived with a television set from the day I was born. *Hopalong Cassidy* and *The Lone Ranger* were the two shows I remember best, but the afternoon programming during my preschool years also featured a daily onslaught of B Westerns from the thirties and early forties, in particular those starring handsome, athletic Buster Crabbe and

his old geezer sidekick, Al St. John. Everything about those films and shows was pure claptrap, but at three and four and five I was too young to understand that, and a world sharply divided between men in white hats and men in black hats was perfectly suited to the thwarted capacities of my young, primitive mind. My heroes were good-hearted dumbbells, slow to anger, reluctant to talk, and shy around women, but they knew right from wrong, and they could out-punch and outshoot the crooked ones whenever a ranch or a herd of cattle or the safety of the town were threatened.

Everyone carried a gun in those stories, both heroes and villains alike, but only the hero's gun was an instrument of righ-teousness and justice, and because I did not imagine myself to be a villain but a hero, the toy six-shooter strapped to my waist was a sign of my own goodness and virtue, tangible proof of my idealis-tic, make-believe manhood. Without the gun, I wouldn't have been a hero but a no one, a mere kid.

I longed to own a horse during those years, but not once did it occur to me to wish for a real weapon or even to fire one. When the chance finally came to do that, I was nine or ten and had long outgrown my infantile dreamworld of television cowboys. I was an athlete now, with a particular devotion to baseball, but also a reader of books and a sometime author of wretchedly bad poems, a boy plodding along the zigzag path toward becoming a bigger boy. That summer, my parents sent me to a sleepaway camp in New

Hampshire, where in addition to baseball there was swimming, canoeing, tennis, archery, horseback riding, and a couple of sessions a week at the shooting range, where I first experienced the pleasures of learning how to handle a .22-caliber rifle and pumping bullets into a paper target affixed to a wall some twenty-five or fifty yards away (I forget the exact distance, but it seemed just right to me at the time—neither too close nor too far). The counselor who instructed us knew his business well, and I have vivid memories of being taught how to position my hands when holding the rifle, how to line up the target along the sight at the end of the barrel, how to breathe properly when preparing to shoot, and how to pull back the trigger in a slow, smooth motion to send the bullet surging through the barrel into the air. My eyesight was sharp back then, and I caught on quickly, first from a prone position, where I once scored a forty-seven out of a possible fifty from the five shots that made up a round, and then from a sitting position, which entailed a whole new inventory of techniques, but just as I was about to advance to the kneeling position, the summer ended, and so ended my career as a marksman. My parents decided that the camp was too far away and sent me to another one less than half the distance from home the following summer, where riflery was not on the menu of activities. A small disappointment, perhaps, but in all other ways the second camp was superior to the first, and I didn't give the matter much thought. Nevertheless, more than

sixty years later, I still remember how good it felt to fire a shot clear into the bullseye, which brought with it a sense of fulfillment similar to the one I experienced whenever I dashed out from my position at shortstop to catch a relay throw from the left fielder and then wheeled around to throw the ball to the catcher as a runner steamed around third base and headed for home. A sense of connection between myself and someone or something a great distance from me, and to throw a ball or fire a bullet and hit the target for the sake of some predetermined goal—to prevent a run from crossing the plate, to run up a high score at the shooting range—produced a deep, glowing sense of satisfaction and achievement. The connection was what counted, and whether the instrument of that connection was a ball or a bullet, the feeling was the same.

The next chance I had to fire a gun came when I was fourteen or fifteen. By then, my passion for sports had expanded beyond baseball to include football and basketball as well, and whether I was playing tackle or touch or full-court or half-court, the connection with someone or something a great distance from me was still the most inspiriting part of the game—sinking a jump shot from fifteen or twenty feet out or, in my role as quarterback, heaving a pass forty yards downfield that fell into the arms of my sprinting receiver for a long gain or touchdown. One of my closest friends during those years came from a wealthy family, and not long after his father had acquired a gentleman's hobby-farm in

Sussex County, I was invited out there one Saturday or Sunday in mid-November. Most of that visit is lost to me now, but what stands out and has never been forgotten is the hour or two hours we spent skeet shooting in that chilly rural landscape of bare branches and swooping, clamoring crows. Not a .22 rifle this time but a double-barreled shotgun, a heftier, more imposing piece of equipment with a stronger recoil, and no longer was I shooting at a paper target affixed to a wall but at an airborne moving object—a round black disc called a clay pigeon that was launched from a device on the ground and sent flying upward, and as I took aim at the black thing streaking across the gray-white sky, I knew that I had to act quickly or the disc would fall to the ground before I had a chance to fire. Oddly enough, it didn't feel difficult to me, and even on the first try I was able to judge the speed and trajectory of the disc and therefore to know how far in front of the target I should aim, so that once the cartridge was winging its way through the air, it would collide with the thing cruising toward it. My first shot was a direct hit. The clay disc burst apart in midair and fell to the ground in tiny fragments, and then, moments later, when the second clay pigeon was launched, I did it again with my next shot. Beginner's luck, perhaps, but I felt strangely confident, and as I waited for my friend and his father to take their turns, I told myself that it must have had something to do with all the footballs I had thrown in the past two or three years. More than that, I also

5

understood that much as I had enjoyed shooting at stationary targets in New Hampshire, this kind of shooting was far more satisfying. First of all, because it was more difficult, but also because it was much more fun to blast apart a clay pigeon than to put a hole in a piece of paper. For the rest of the afternoon, I didn't miss once.

Given how naturally I had taken to this new sport, I find it somewhat mystifying that I didn't go any further with it. Even in New Jersey, I'm sure it would have been possible to find a gun club somewhere and go on shooting once or twice a week for as long as I wished, but for all the enjoyment I had felt that day on the farm, I simply let the matter drop. Even more mystifying, not once in the many years since then have I held another rifle or shotgun in my hands.

For want of any other explanation, I suspect that my indifference to guns came from the fact that nothing in my background had disposed me to care about them. Neither my father nor my mother nor anyone else in our extended family owned a firearm, and none of them had anything to do with hunting birds or beasts or shooting for sport or ever talked about buying a handgun or a rifle to protect the household against a criminal invasion. The same held true for all my friends and their families, and even though stories about gangland murders filled the newspapers of the 1950s, I don't recall a single instance when a person in my town brought up the subject of guns. Young boys who lived out in the country hunted wild animals with their fathers, tough, impoverished boys from the big cities

went after one another with homemade zip guns, earning the label "juvenile delinquents," but in my mostly tranquil suburban world, which had its fair share of delinquents as well, guns were not an issue. Not even during those years when twenty or thirty Westerns aired weekly on television and Hollywood studios were cranking out dozens of Technicolor pictures about the Wild West. Add in the many gangster films and television shows that were also produced in the fifties and early sixties, and millions of big screens and small screens from one end of America to the other were awash in images of gun violence. I enjoyed that mayhem as much as anyone else, but for all the scenes I watched of shoot-outs, ambushes, and men writhing on the ground with mortal wounds, they had little effect on me. The guns were merely props in carefully staged cinematic productions, and the blood that spilled from the wounded men was red paint or, in the case of movies and shows filmed in black-and-white, Hershey's chocolate syrup. My dream life as a Texas cowboy had ended years before, and based on what I had seen of the old frontier's twentieth-century equivalents, I also understood that I had no intention of growing up to become a gangster, a bank robber, or— perish the thought—a G-man.

Had I come from a different background, there is every chance I would have embraced guns as an integral part of my life. Such is the case for tens of millions of Americans across the country, and if I had grown up elsewhere with another set of parents in

another sort of community, and if I had been encouraged by my father to take up shooting as one of the fundamental imperatives of manhood, a boy with my innate marksmanship talents surely would have followed his example with enthusiasm. But my father was not one of those men, and therefore I was not one of those boys. More than that, there was something I didn't know, an essential something that lay buried in the ground throughout my childhood and into my early twenties, but once that thing was pulled up into the light, I finally understood how much my father must have abhorred guns and how badly his life had been scarred by the brutality of guns when real bullets are fired into a real human body.

From the beginning of my conscious life, I had always known that my paternal grandfather had died when my father was a young boy. I had two grandmothers but only one grandfather, and the shadow of that missing person often swept over my thoughts, prompting me to speculate about who that man might have been and what he had looked like, since there were no photographs of him anywhere in our house. As I remember it, at three different times in my early childhood, I asked my father how his own father had died. There was always a pause before he answered, and each time he gave me the story, it was different from the one he had told earlier. The first time I asked, he said that his father had been repairing the roof of a tall building and had died when he slipped off the edge and fell to the ground. The second time, that he had been killed in a

hunting accident. The third time, that he had been killed as a soldier in World War I. I was no more than six or seven, but I had lived long enough to know that a person dies only once, not three times, yet for reasons I don't fully understand, I never challenged my father to explain the contradictions in his stories. It could be that because he was such a remote, silent person, I had already learned to respect the distance between us and to stand obediently on the other side of the wall he had built around himself. To break through that wall and effectively accuse him of lying was therefore not within the realm of the possible. I have a dim memory of going to my mother and asking her about the three different stories my father had given, but her answer was just as puzzling to me. "He was so young at the time," she said, "he probably doesn't know how it happened." But that made no sense either. My father was the youngest of five children, and surely one of his older siblings would have told him, even if his mother had refused to talk about it. As the third youngest of nine first cousins, I eventually asked four or five of the oldest ones if they had ever been told anything about our grandfather's death, and one by one they all said that they had received the same sorts of evasive answers to their questions that I had. The four Auster brothers and their sister had chosen to hide the truth from their children, and not one of us from the younger generation had any hope of ever cracking the mystery of what had happened to our grandfather, who had died long before any of us was born.

Years passed with no progress on any front, and then, through a wholly improbable trick of chance that seemed to overturn every rational assumption about how the world is supposed to work, one of those older cousins happened to find herself sitting next to a stranger on a transatlantic flight in 1970, and that man, who had grown up and still lived in Kenosha, Wisconsin, the same small city where our fathers had lived with their parents in the years before and during World War I, uncovered the secret that had been hidden for the past five decades. Because of who my father was, and because of who I had become by then, I never said a word to him about it for the rest of his life, which lasted close to nine more years after that. I knew what he knew, but he never knew that I knew. Whatever his motive had been, he had protected me with his silence when I was young, and now I meant to do the same thing for him when he was old.

The truth comes down to this: On January 23, 1919, two months after the end of World War I, at the beginning of the third wave of the Spanish flu pandemic that had broken out the previous year, and just one week after the ratification of the Eighteenth Amendment to the Constitution, which banned the production, transport, and sale of intoxicating liquors in the United States, my grandmother shot and killed my grandfather. Their marriage had broken up at some point within the past year or two. Following the separation, my grandfather had moved out and settled in Chicago, where he was now living with another woman, but he came

back to Kenosha that Thursday evening in 1919 to give presents to his children, and while he was paying what he no doubt imagined would be a short visit, my grandmother asked him to repair a faulty light switch in the kitchen. The electricity was turned off, and as the second youngest Auster son held a candle for him in the darkened room, my grandmother went upstairs to tuck in her youngest for the night (my father) and to retrieve the pistol she kept hidden under the little boy's bed, whereupon she went back downstairs, reentered the kitchen, and fired several shots at her estranged husband, two of which entered his body, one in the hip and the other in the neck, which must have been the one that killed him. The Kenosha newspapers announced his age as thirty-six, although I suspect he might have been a few years older than that. My father was six and a half, and my uncle, the boy holding the candle who had witnessed the murder, was nine.

There was a trial, of course, and after my grandmother was unexpectedly acquitted on the grounds of temporary insanity, she and her five children left Wisconsin and headed east, eventually landing in Newark, New Jersey, where my father grew up in a wrecked family presided over by a hotheaded, often unhinged matriarch who trained her children never to breathe a word among themselves or to anyone else about what had happened in Kenosha. Resources were pinched, day-to-day life was a struggle, and even though all four boys had after-school jobs, coming up with the rent from month to month was

often a problem, which meant that they moved several times a year to escape angry landlords, which in turn meant that the boys kept changing schools as they bounced from one neighborhood to another. So many friendships interrupted, so many potential bonds broken, until all they could count on in the end was one another. This was not the genteel poverty of a family that had come down slightly in the world but the rough poverty of a family that had fallen close to the bottom, with all the attendant stress, anxiety, and bouts of panic that come from never having enough.

The gun had caused all this, and not only did the children have no father, they lived with the knowledge that their mother had killed him. Nevertheless, they loved her—stubbornly, ferociously, and no matter how deranged she could be at times or how capriciously she acted with them, they held fast and never faltered in their devotion.

When we talk about shootings in this country, we invariably fix our thoughts on the dead, but seldom do we discuss the wounded, the ones who survive the bullets and go on living, often with devastating permanent injuries: a shattered elbow that renders an arm useless, a pulverized kneecap that turns a normal stride into a painful limp, or a blown-apart face patched together with plastic surgery and a prosthetic jaw. Then there are the victims whose bodies were never touched by gunfire but who go on suffering from the inner wounds of loss—a maimed sister, a brain-injured brother, a dead father. And if your father is dead

because your mother shot and killed him, and if you go on loving your mother in spite of that, it is almost certain that you will gradually succumb to living in a state of so many crossed mental wires that a part of you will begin to shut down.

The three oldest children, who had been mostly formed by the time of the murder, had an easier time adjusting to their new reality than the two youngest ones, my six-and-a-half-year-old father and my nine-year-old uncle. The boy who witnessed the murder grew up into a successful but haunted man given to savage bursts of rage, horrific jags of shouting, screaming, and uncontrollable anger that could build to hurricane force and knock down walls, houses, and whole cities during his most violent tantrums. As for my largely subdued father, he worked hard at transforming his radio repair shop into a full-fledged appliance business and remained a feckless, freelancing bachelor who lived at home with his mother until he was thirty-three. In 1946, he married my twenty-one-year-old mother, a woman he supposedly worshipped but could not love, for by then he was a lonely, fractured man whose inner ground was so murky that he lived at a remove from himself and others, which made him unqualified for marriage, and so my parents eventually divorced, and whenever I think about the essential goodness of my father and what he could have become if he had grown up under different circumstances, I also think about the gun that killed my grandfather—which was the same gun that ruined my father's life.

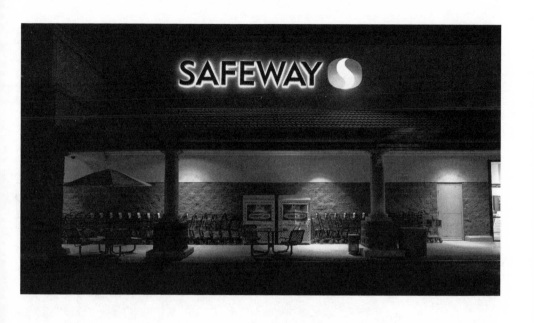

Safeway supermarket parking lot.
Tucson, Arizona. January 8, 2011.
6 people killed; 15 injured (13 by gunfire).

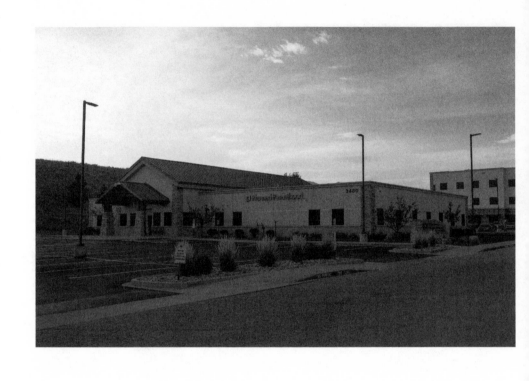

Planned Parenthood center.
Colorado Springs, Colorado. November 27, 2015.
3 people killed; 9 injured.

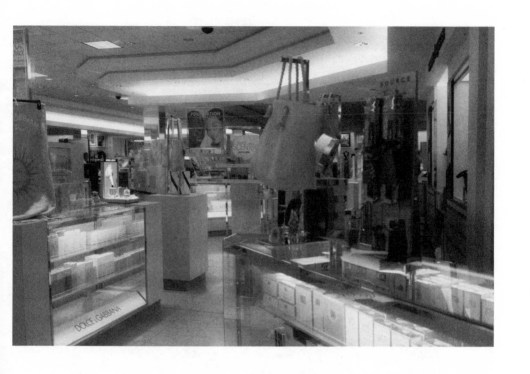

Macy's department store, Cascade Mall.
Burlington, Washington. September 23, 2016.
5 people killed.

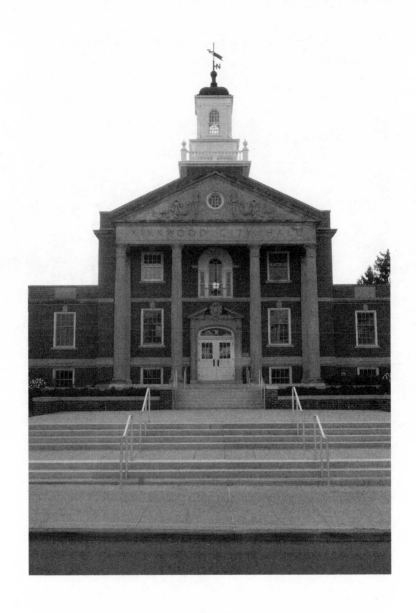

City Hall.
Kirkwood, Missouri. February 7, 2008.
7 people killed; 1 injured.

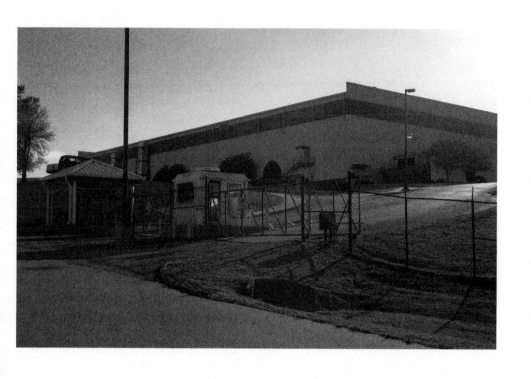

Lockheed Martin plant.
Meridian, Mississippi. July 8, 2003.
7 people killed; 8 injured.

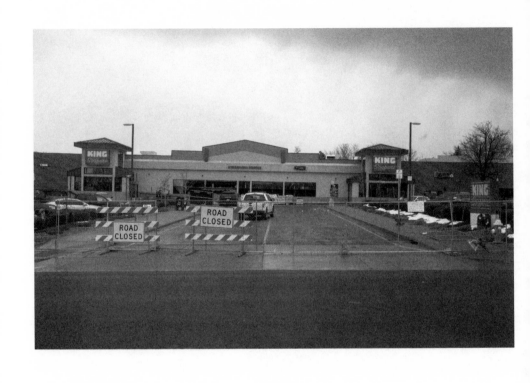

King Soopers supermarket.
Boulder, Colorado. March 22, 2021.
10 people killed; 2 injured.

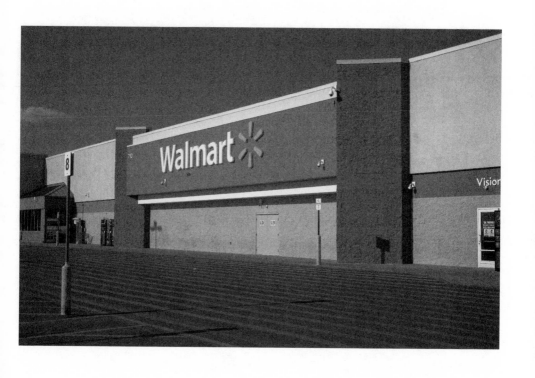

Walmart.
El Paso, Texas. August 3, 2019.
23 people killed; 23 injured.

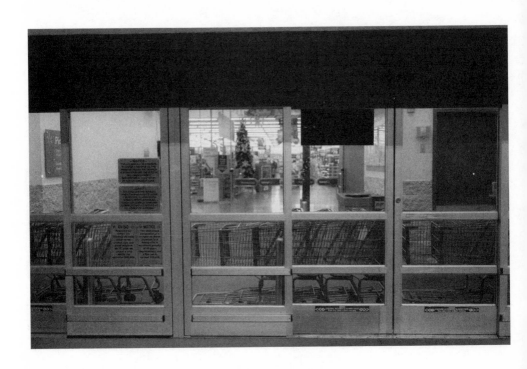

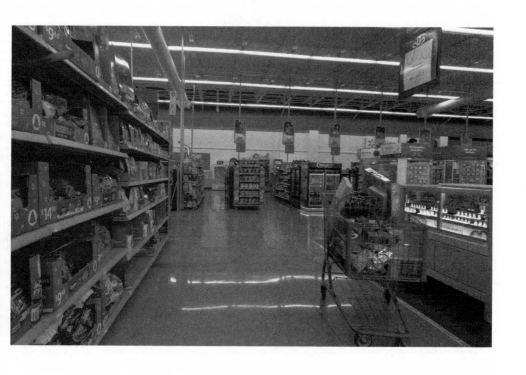

2

In 1970, the year I learned about that gun, I began a six-month stint in the merchant marine, employed as an ordinary seaman on an Esso oil tanker, and it was aboard that ship that I first came into contact with men who had grown up around guns and continued to live on intimate terms with them. For the most part, our cargo consisted of jet fuel, which we hauled up and down the Atlantic coast and into the Gulf of Mexico. Elizabeth, New Jersey, and Baytown, Texas, the sites of two of Esso's largest refineries, were the end points of all our journeys, with customary stops in Tampa and other ports along the way. There were just thirty-three men on board, and apart from a couple of Europeans and a handful of Northerners like myself, every officer and member of the crew came from the South, nearly all of them from Louisiana and various towns along the Texas coast. Two of those shipmates jump back into my thoughts now, not because they were especially close friends of mine but because each of them, in his own vastly different way, was instrumental in furthering my education about guns.

Lamar was a short, stringy-haired redhead from Baton Rouge with a bright crimson splotch marring the white of his left eye and eight letters tattooed onto the knuckles of his two hands: L-O-V-E and H-A-T-E, the same marks inscribed onto the

fingers of Robert Mitchum's demented preacher in *The Night of the Hunter*. Lamar worked as an assistant oiler in the engine room and was approximately my age (twenty-three). In spite of the bad-boy tattoos, I found him to be a soft-spoken, agreeable sort, and because we were fellow newcomers on our first ship, he took it for granted that we were allies and seemed to enjoy hanging out with me when we weren't busy with our jobs. The fact that I was from the North and had graduated from college and had published some poems in magazines were not things he looked upon with suspicion. He took me as I was, I took him as he was, and we got along—not quite friends, exactly, but shipmates on easy, friendly terms. Then came the first revelation, the first jolt. We had shared enough stories about ourselves by then for me to feel that I wouldn't be offending him if I asked about the red splotch in his eye. Taking no offense, Lamar calmly explained that it had happened a few years back when he and a crowd of people were standing on a sidewalk throwing bottles at a protest march led by Martin Luther King. A shard of broken glass had flown into his eye and pierced the membrane, causing a wound that had healed over into the ugly red thing that would be with him for the rest of his life. Still and all, it could have been a lot worse, he said, and he felt lucky not to have lost the eye.

Until then, Lamar had never said a word against Black people in my presence, and when I asked him why he had done

such a stupid, vicious thing, he shrugged and said it had seemed like a fun thing to do at the time. He was in his teens then and hadn't known any better, implying that he wouldn't do that sort of thing today. Not that he could have, of course, given that Martin Luther King had been shot down and killed two years earlier, but I chose to interpret his words as an apology, even though I had my doubts. Then came the second revelation. We were standing on the deck one afternoon watching a flock of gulls circling above the ship when Lamar told me about another one of the fun things he liked to do on Saturday nights in Baton Rouge when he was feeling bored, which was to take his rifle and a pocketful of ammunition, park himself on an overpass of the interstate highway, and shoot at cars. He smiled at the memory of it as I tried to absorb what he was telling me. Shooting at cars, I said at last, you must be pulling my leg. Not at all, he answered, he really did it, and when I asked if he aimed at the drivers or the passengers or the gas tanks or the tires, he vaguely answered that he shot in the general direction of all of them. And what if he hit and killed someone, I asked, what would he do then? Another one of Lamar's shrugs, followed by a laconic, indifferent, almost blank "Who knows?"

Those two jolts occurred during my first ten or twelve days on the ship, I kept a polite distance between myself and Lamar for several days after that, and then he came to me one afternoon

as we were nearing a port and said goodbye. The chief engineer didn't like his work, he said, and he had been given the boot. Earlier, he had told me that he had gone through a rigorous training course and had passed a written exam to qualify as an oiler, but it turned out that Lamar had cheated on the exam and knew as much about being an oiler as I did. As the chief engineer later put it to me: "That little son-of-a-bitch could have blown up the tanker and every living soul on board, so I kicked his sorry ass out of here."

So much for my departed comrade, my onetime pal. Not just a bottle-throwing racist, not just a dangerous fraud, but a hollowed-out psychopath who thought nothing about pointing his rifle at anonymous strangers and shooting at them for no other reason than the kick of it, the pleasure of it. Put a gun in the hands of a maniac, and anything can happen. We all know that, but when the maniac appears to be a levelheaded, ordinary fellow with no chip on his shoulder or apparent grudge against the world, what are we to think and how are we supposed to act? To my knowledge, no one has ever provided a satisfactory answer to this question.

Billy was a different sort of animal—tame, sweet-tempered, and young, just eighteen or nineteen, by far the youngest member of the crew. I was the second youngest, but next to the blond, smooth-faced Billy, I felt positively old. A pleasant kid from a

small rural town in Louisiana, he talked mostly about his passion for souped-up cars and hunting deer with his father, whom he referred to as "Daddy" and "my daddy." We went ashore together a couple of times with the forty-year-old Martinez, a family man from Texas, but apart from liking Billy and promising to go hunting with him one day if and when I happened to find myself in Louisiana, I didn't know him well. None of that is of any importance now. Fifty years later, what counts is that on one of our stops in Tampa, we left the ship with Martinez, and as the three of us waited for a taxi to pick us up and drive us into town, Billy made a collect call home from the pay phone on the dock. He talked to his father or mother for what seemed to be an inordinate length of time, and after he hung up, he turned to us with a troubled look on his face and said: "My brother's been arrested. He shot someone in a bar last night, and now he's locked up in the county jail."

There was nothing more than that. No word on why his brother had shot that someone, no word on whether that someone was alive or dead, and if alive whether he was badly wounded or not. Just the bare bones of it: Billy's brother had shot someone, and now he was in jail.

With nothing more to go on than that, I can only speculate. If Billy's older brother was anything like Billy himself, that is, a good-natured, reasonably balanced, functioning human being and

not some trigger-happy nutjob like Lamar, there is every chance that the shooting of the previous night was caused by an argument, perhaps with an old friend, perhaps with a stranger, and that the disinhibiting effects of alcohol played a decisive part in the story as well. One beer too many, and a verbal dispute suddenly and unexpectedly explodes into a punching match. Such things happen every night in bars, pubs, and cafés all across the world, but the bloody noses and aching jaws that generally follow from these dustups in Canada, Norway, or France often turn out to be gunshot wounds in the United States. The numbers are both stark and instructive. Americans are twenty-five times more likely to be shot than their counterparts in other wealthy, so-called advanced countries, and with less than half the population of those two dozen other countries combined, eighty-two percent of all gun deaths take place here. The difference is so large, so striking, so disproportionate to what goes on elsewhere, that one must ask why. Why is America so different—and what makes us the most violent country in the Western world?

West Nickel Mines School (a one-room Amish schoolhouse).
Bart Township, Lancaster County, Pennsylvania. October 2, 2006.
6 people killed; 5 injured.
All the victims were girls between the ages of 6 and 13. The school
was demolished the following week and left as open pasture. Another school was
erected in a nearby location six months later.

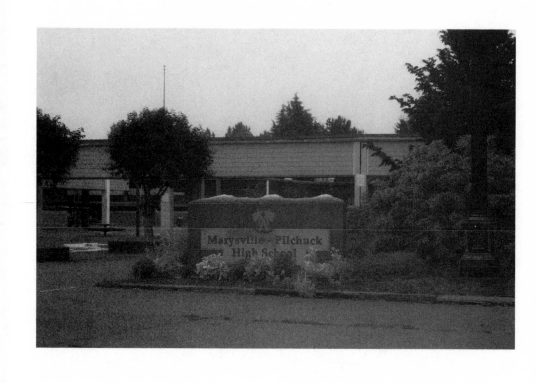

Marysville-Pilchuck High School.
Marysville, Washington. October 24, 2014.
5 people killed; 3 injured.

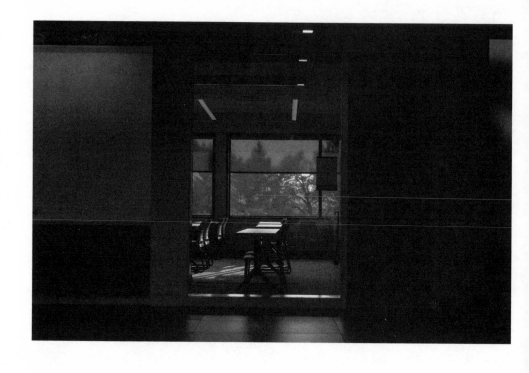

Umpqua Community College.
Roseburg, Oregon. October 1, 2015.
10 people killed; 9 injured.
The building where the shootings took place was torn down,
and a new structure was built on the site.

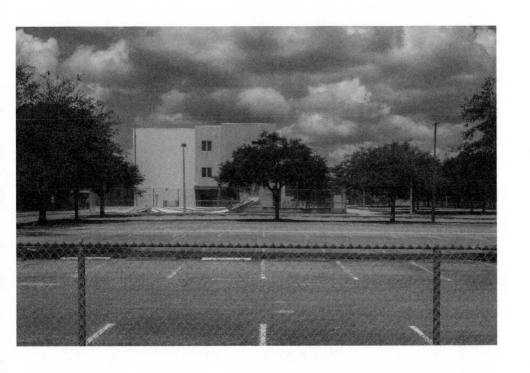

Marjory Stoneman Douglas High School.
Parkland, Florida. February 14, 2018.
17 people killed; 17 injured.
The building where the shootings took place was torn down,
and a new structure was built on the site.

3

According to a recent estimate by the Children's Hospital of Philadelphia Research Institute, there are 393 million guns currently owned by residents of the United States—more than one firearm for every man, woman, and child in the country. Each year, approximately forty thousand Americans are killed by gunshot wounds, which is roughly equivalent to the annual rate of traffic deaths on American roads and highways. Of those forty thousand gun fatalities, more than half of them are suicides, which in turn account for half of all suicides per year. Add in the murders caused by guns, the accidental deaths caused by guns, the law enforcement killings caused by guns, and the average comes out to more than one hundred Americans killed by bullets every day. On that same average day, another two-hundred-plus are wounded by guns, which translates into eighty thousand a year. Eighty thousand wounded and forty thousand dead, or one hundred and twenty thousand ambulance calls and emergency room cases for every twelve-month tick of the clock, but the toll of gun violence goes far beyond the pierced and bloodied bodies of the victims themselves, spilling out into the devastations visited upon their immediate families, their extended families, their friends, their fellow workers, the people of their neighborhoods, their schools,

their churches, their softball teams, and communities at large—
the vast brigade of lives touched by the presence of a single
person who lives or has lived among them—meaning that the
number of Americans directly or indirectly marked by gun vio-
lence every year must be tallied in the millions.

Those are the facts, but helpful as it is to look at the figures
that support those facts, they do not answer the question of why
America and nowhere else. Bloodshed and death on this scale and
at this level of frequency would seem to call for national action, a
concerted effort on the part of state, federal, and municipal govern-
ments to control what by any measure of rational understanding is
a public health crisis. America's relationship to guns is anything
but rational, however, and therefore we have done little or noth-
ing to fix the problem. It's not that we lack the intelligence or the
wherewithal to relieve this threat to the safety and well-being of
society, but for complex historical reasons, we have lacked the will
to do so, and so obdurate have we become in our refusal to address
the problem that in 1996 the CDC (Centers for Disease Control
and Prevention) was barred by Congress from using federal funds
to conduct research that "may be used to advocate or promote gun
control." By contrast, consider the progress we have made with
the cars we drive and how conscientiously we have pushed down
the death and injury rates caused by automobile accidents over
the years. And make no mistake about it: Cars are not terribly

different from guns. A high-powered automatic rifle and a four-thousand-pound Chevy barreling down a highway at seventy or eighty miles an hour are both lethal weapons.

The car has been with us since the tail end of the nineteenth century, and at the beginning of its life the horseless carriage was seen as nothing more than a faster, motorized version of the horse-drawn carriage. Consequently, there were no laws or regulations governing its use: no licenses, for example, which meant no road tests to prove one's competence behind the wheel, no stop signs, no traffic lights, no speed limits, no brake signals, no rearview or side-view mirrors, no left- or right-turn signal lights, no penalties for drunken driving, no shatterproof windshields, no padded dashboards, and no seat belts. Bit by bit, over the better part of the twentieth century, each one of those improvements was made—made and enforced by law—and the roads, streets, and highways of the country have become safer because of it. There are still an appalling number of traffic deaths in America every year, but compared to the dizzying smashup rates of the twenties, thirties, and forties, the percentage of accidents per total miles driven by more than three hundred million Americans in close to three hundred million registered vehicles—trucks, vans, passenger cars, buses, and motorcycles—has in fact been vastly reduced. Which begs the question: If we could face up to the dangers represented by cars and use our

brains and sense of common purpose to combat those dangers, why haven't we been able to do the same thing with guns?

Guns have been around a lot longer than cars, of course, but cars are much bigger than guns and therefore more visible, and after circulating among us for the past one hundred and twenty years, they have established a hold on the American imagination no less dominant than the spell cast by our passion for guns. Cars and guns are the twin pillars of our deepest national mythology, for the car and the gun each represents an idea of freedom and individual empowerment, the most exciting forms of self-expression available to us: Dare yourself to push the gas pedal to the floor, and suddenly you are racing along at one hundred miles an hour; curl your fingers around the trigger of your Glock or AR-15, and you own the world. Nor do we ever tire of watching and thinking about those things. The two most beloved components of American films have long been the shoot-out and the car chase, and no matter how many times we have lost ourselves in the spectacle of those deftly orchestrated thrill-a-thons as they played out on-screen, we still go back for more.

On the other hand, for all the similarities between cars and guns, there are fundamental differences as well. Guns exist for the sole purpose of destroying life, whereas cars are manufactured to carry the living from one place to another, and even if too many drivers, passengers, and pedestrians happen to be

killed in cars and because of cars, we call their deaths *acciden-tal*, a tragic by-product of the risks and dangers of the road. By contrast, nearly every death by gun is *intentional*, whether the person using the gun is a soldier in battle, a hunter stalking deer in the woods, a deranged or cold-blooded murderer on a city street or in the kitchen of someone's house, an armed robber who panics while holding up a jewelry store, or a crushed, despairing soul who downs half a bottle of bourbon in a dark room and then fires a bullet into his head. Cars are a necessity of civilian life in America. Guns are not, and as more and more Americans have come to understand that, the percentage of households that own guns has been dropping steadily over the past fifty years, from half of them to a third of them to what is now somewhere just below a third, and yet the number of guns currently owned by Americans is larger than ever before—which means that fewer and fewer people are buying more and more guns.

How to account for this great difference, and why at this moment in our history have Americans been pulling farther and farther apart on the subject of guns, leading to a situation in which most of us want little or nothing to do with them and some of us—a minority that contains millions—have fetishized them into emblems of American freedom, an essential human right granted to all citizens by the framers of the Constitution? Fifty years ago, when I was traveling through the waters of the Gulf of

Mexico as an ordinary seaman, I would have answered that it was simply a matter of where you were born and how you were raised and what was expected of you from your family and community. If I had grown up in rural Louisiana as my shipmate Billy had, it is almost certain that hunting would have become a normal activity for me, but given that I was born elsewhere and raised differently and was not expected to learn how to shoot animals, it didn't. Politics had nothing to do with it—not in my case, not in Billy's—and lest we have forgotten where we are, the year I am talking about is 1970, smack in the middle of the Vietnam War, which divided Americans then almost as sharply as we are divided now, but even in that time of massive anti-war demonstrations, of urban revolt and mayhem, of multiple assassinations of our most prominent leaders (John F. Kennedy, Malcolm X, Martin Luther King, Robert F. Kennedy), guns had not yet become a burning political issue, even if handguns and high-powered, long-distance rifles were the instruments that made those murders possible.

The logical next step would be for me to start talking about the growth of the NRA, the Second Amendment, the gun-control movement, and the various positions advanced by partisans on both sides of the issue, but all those arguments and counter-arguments are numbingly familiar to us by now, and beyond that, and above that, there is the more important fact that the immense

problem we are facing as a country is not likely to be solved by enacting new laws or rescinding old laws or pushing innovative safety measures through Congress. Piecemeal legislation might help mitigate some of the damage, but it will never go to the heart of the problem, and given that we have failed to use our common sense to confront gun violence as a public health menace, as we have with automobile accidents, cigarette smoking, asbestos, aerosol spray cans, and countless other harmful symptoms of modern life, I can't imagine that we would fare any better by looking beyond Congress to the courts as the final arbiter on what to do and what not to do. One side will win, the other side will lose, and at the same moment the winners are exulting in their victory, the losers will cry out in anger that a gross injustice has been committed, and we will be right back where we are now.

In order to understand how we got here, we have to remove ourselves from the present and go back to the beginning, back to the time before the United States was invented and America was no more than a sparsely populated collection of white settlements scattered among thirteen distant outposts of the British Empire. Our colonial prehistory lasted one hundred and eighty years, and most of that chaotic, formative time was lived in a state of unending armed conflict. For the same reason that other European kingdoms felt little or no compunction about conquering and subduing indigenous populations across the seas (Spain,

Portugal, France, Holland), the English-born American colonists persuaded themselves that they had a God-given right to inhabit any and all parts of the New World wilderness they now called home, even if it meant displacing the people who happened to occupy those lands—and had been occupying them for thousands of years before the arrival of the English. There is no need to comment on how the Indians reacted to the aggressive, uncompromising position of their new neighbors, nor will I march through the dismal catalogue of wars fought between local tribes and colonists in the seventeenth and eighteenth centuries, which included countless raids on Indian villages and often led to massacres—the righteous slaughter of every man, woman, and child who lived there, after which every dwelling in the village was torched and burned to the ground.

To carry out these military operations, the colonists organized militias composed of all able-bodied men over the age of sixteen. Not only was every man required to equip himself with a musket at his own expense—making gun ownership more than just a right but an obligation, a civic duty—but every man was also required to serve in the militia until he was too old to stand upright and carry a gun, meaning that whether you were a dry goods merchant, a farmer, or a deacon of the church, you were also a career soldier, whether you liked it or not. The colonists considered themselves to be under threat, and unless they all

pulled together to defend themselves against the common enemy, the future of their homes and towns and even their presence in the New Jerusalem they imagined they were creating would be imperiled.

Fear coupled with violence, with bullets as the weapon of first resort. It is a combination that runs through every chapter of our history and continues to be an essential fact of American life today.

Also present today are the lingering effects of another American phenomenon from the early seventeenth century, chattel slavery, the abomination that lasted through the colonial era, survived the founding of the Republic, eventually tore the country apart, and goes on tearing us apart in myriad ways four hundred years after the English imposed their new economic system of no-cost labor performed by kidnapped, subjugated human beings on the thirteen colonies and various Caribbean islands under British rule. To my knowledge, there is nothing on record that shows any resistance on the part of the colonists who stood to profit from this grotesque innovation. When white slavers from Barbados began moving to South Carolina in the 1670s, they imported the practices of slave management they had already established in their former home, among them the creation of a militia force known as the slave patrols, which were absorbed into the larger militias dedicated to fighting and exterminating Indians and were empowered to oversee a code of regulations

whereby (among other things) all enslaved people sent out on errands by their masters were required to show a pass to any white person who stopped and questioned them, and, to ensure the preservation of an economy built on no-cost labor, were given a free hand to round up and capture runaway slaves. So began the centuries-long tradition of frantic Black men thrashing through swamps, pursued by packs of yelping bloodhounds trained for the sole purpose of hunting down fugitives, and once the men had been caught, they were flogged by whips until their backs bled and then hauled back to their masters. In effect, the slave patrols constituted the first police forces in America, and until the end of the Civil War, they functioned as a kind of Southern gestapo.

In time, the war against the Indians and the war to protect the institution of slavery carried on in full force as Americans began the long process of expanding their territory beyond the thirteen colonies. There was good money to be made by appropriating the land west of the Alleghenies in the Ohio Valley, also known as Indian Territory, and by the mid-eighteenth century and all through the French and Indian War (1754–1763), American colonists were extending the boundaries of their world, none more cleverly and profitably than surveyor-soldier George Washington, who amassed a fortune in land speculation while still in his twenties and early thirties. Slavery spread into these

new regions, and many Indians were slaughtered in the process of turning that fertile soil into white territory, but when the war ended with England's victory over France, the British tried to put a stop to the colonists' insatiable land hunger. In her deeply researched and persuasively argued book about the history of guns in America, *Loaded* (2018), Roxanne Dunbar-Ortiz neatly summarizes the situation and shows how this conflict over land was one of the primary causes of the Revolution:

> To the settlers' dismay, soon after the 1763 Treaty of Paris was signed, King George III issued a proclamation prohibiting British settlement west of the Allegheny-Appalachian mountain chain, ordering those who had settled there to relinquish their claims and return to the kingdom's thirteen colonies. Soon it became clear that the British authorities needed far more soldiers to enforce the edict, as thousands of settlers ignored it and continued to pour over the mountains, squatting on Indigenous lands, forming armed militias, and provoking Indigenous resistance. In 1765, in order to enforce the Proclamation line, the British Parliament imposed the Stamp Act on the colonists, a tax on all printed materials that had to be paid in British pounds, not local paper money. The iconic colonial protest slogan "taxation without representation is tyranny" marked the

surge of rebellion against British control but it did not tell the whole story, considering what the tax was for: to pay the cost of housing, feeding, and transporting soldiers to contain and suppress the colonies from expanding further into Indian territory.

Ten years after the Stamp Act, fighting began between British soldiers and American colonists in and around Boston. One year after that, the Declaration of Independence set forth the reasons for and the purpose of the rebellion: to establish a separate, self-governing country free of British rule. The second paragraph famously begins with the words: "We hold these truths to be self-evident, that all men are created equal, that they are endowed by their Creator with certain unalienable Rights, that among them are Life, Liberty, and the pursuit of Happiness."* These words continue to stand as holy doctrine in the American mind, the bedrock credo on which the Republic

* Note that according to the grammatical conventions of the time, the phrase *all men* implied all women as well. Theoretically, at any rate, but in point of fact women did not have equal standing in American society—not during the colonial era and not after the founding of the Republic. For one example among many, consider that women were not granted the right to vote until 1920. One hundred years later, the struggle for full equality goes on.

was founded, and yet, as everyone famously knows, the words are a lie and were known to be a lie on the day they were published, for *all men* means ALL MEN, and *equal* means EQUAL, and *liberty* means LIBERTY, and for the newly declared republic to make that assertion when vast numbers of people who dwelled within its territory were enslaved and therefore not equal and denied liberty and were in fact considered to be chattel, that is, an article of personal, movable property, in the same way a pig or a dog or a buckboard wagon are personal property, was an exercise of such sublime hypocrisy as to render that assertion meaningless. The moment demanded that slavery be abolished right then and there—as a central clause in our founding document—but as everyone in the world famously knows, it wasn't.

The twenty-six-year-old Thomas Jefferson, the boy wonder who wrote the first draft of the Declaration, was perhaps the purest example of the ontological conflict that lay at the heart of the American project. The son of a wealthy slave-owning family, he nevertheless understood (in his own words) that slavery was a "hideous blot" and a "moral depravity," even as he maintained a property with six hundred slaves on it and fathered half a dozen children with his dead wife's enslaved, mixed-race half-sister, Sally Hemings. And yet, back in the summer of 1776, at that early moment in his long career, Jefferson felt

compelled to address the issue of slavery in his original draft of the Declaration. Among his long list of grievances against the British king are the following two denunciations:

> —He has waged cruel war against human Nature itself, violating its most sacred Rights of Life and Liberty in the Persons of a distant People who never offended him, captivating and carrying them into slavery in another Hemisphere, or to incur miserable Death in their Transportation thither.

> —Determined to keep open a Market where men should be bought and sold, he has prostituted his Negative for Suppressing every legislative Attempt to prohibit or to restrain this execrable Commerce.

Harsh words, but not harsh enough, for while Jefferson rightly condemns the king for having brought this "execrable Commerce" to the New World, he says nothing about the colonists' active and willing participation in it, and nowhere does he suggest that slavery should be abolished. Even so, the two paragraphs were dropped from the final draft of the Declaration in a compromise with the Southern colonies to secure their cooperation in the war with the British. In so doing, the most important idea of the

Declaration—that all men are created equal—was fatally damaged by transforming the word "all" into "some" or "most" and excluding the Black slave population from the ranks of humanity. Black people were the sacrifice that propelled the Revolution forward and led to the founding of the Republic. Eerily, then, as if in anticipation of all that was to follow, at the very moment the signers of the Declaration were bringing that Republic to life, the North was already capitulating to the South in order to maintain the solidarity of a united front, which established the precedent that has continued to sabotage our democracy ever since—allowing a minority to hold the majority captive and bend it to its will, thus giving us a democracy in which a minority rules.

Even worse, this weakened form of government was written into federal law by the men who drafted the Constitution eleven years later, when the South was given disproportionate power through a clause that allowed the states in the region to count each of their slaves as three-fifths of a human being, which in turn would allow them to increase the number of representatives they could elect to Congress. So it was, and so it continued to be until the Thirteenth, Fourteenth, and Fifteenth Amendments were added to the Constitution after the Civil War—and once again, Black people were the sacrifice.

Three-fifths of a person. How I would like to have listened in on the conversations of those enlightened men as they split

hairs over how to determine what fraction of a human life they should allot to a slave. If Jonathan Swift had still been alive then, he could have worked the scene into one of the chapters of *Gulliver*, and the whole world would have laughed at his peerless satirical wit.

Lafayette: "I would never have drawn my sword in the cause of America, if I had conceived that thereby I was founding a land of slavery."*

Nevertheless, that compromised land managed to produce a Constitution and thereby establish the rules of government by which we continue to live—a flexible document that "in Order to

* In the long run, the abolition of slavery only increased the minority power of the South, turning the three-fifths into five-fifths, which became a wholly imaginary number when the Southern states maneuvered their way around the Fourteenth and Fifteenth Amendments and disenfranchised Black voters after the end of Reconstruction. In many respects, the Jim Crow era that followed was even more perilous to the Black population than slavery had been, for under the old system Black bodies had been looked upon as property, that is, sources of wealth to be bought and sold, which had provided some small measure of protection to the enslaved. Now that Black bodies had lost their monetary value, they were subject to increasingly violent forms of repression and intimidation. Thousands of Black men and women were lynched during the Jim Crow

create a more perfect Union" has undergone a number of significant changes since it was written in 1787. What we now call the Bill of Rights, which largely dealt with personal freedoms and the protection of the individual, was added to the original text in order to win the support of a sufficient number of states to ensure ratification. Which brings us to the Second Amendment, that ambiguously worded, bizarrely punctuated sentence that sat quietly on the first page of the Bill and was largely ignored for most of our history until it stopped being ignored and suddenly, as if overnight, became the most contentious element in the gun debate that has divided the country for the past fifty years: *A well-regulated Militia, being necessary to the security of a free*

years, and large-scale massacres of free Black communities took place in Wilmington, Atlanta, East Saint Louis, Tulsa, and other cities around the country. Even now, in our supposedly more enlightened era, the ghost of Jim Crow lives on in numerous realms of American society: in the justice system, for example, with unequal sentencing of Black and white criminal offenders and a disproportionate number of Black men swelling the ranks of our prison population, which is the largest in the world; in the workforce, where Black employees are paid substantially less than their white counterparts for identical jobs; and in the housing industry, where the longstanding practice of redlining has made it inordinately difficult for Black families to live in safe, decent neighborhoods.

State, the right of the people to keep and bear Arms, shall not be infringed.

Oceans of ink have been spilled in an ever-mounting flood of arguments and counter-arguments about what those words mean.

Above all things, what most newly independent Americans feared was a federal government that would establish a permanent national army—a standing army of professional soldiers—which they saw as an instrument of tyranny, a repressive shock force deployed by monarchical governments such as the one they had just defeated from the British Empire. Consequently, the colonial militias were reconfigured into state militias, and as set forth in the main body of the Constitution (Article I, section 8, paragraphs 15 and 16), they would be called upon when necessary "to execute the Laws of the Union, suppress Insurrections and repel Invasions" as well as retain control of "the Appointment of the Officers, and the Authority of training the Militia" even when serving the cause of the Union. In other words, at those times when the federal government found it necessary to muster an army, the troops and officers would be drawn from the state militias. In light of those two paragraphs, which clearly acknowledge the existence of the militias along with their right to go on existing, it seems odd, or at least redundant, that the framers should have returned to the subject of militias in the Second

Amendment, which appears to do nothing more than to assert that the people—men people—have the right to join militias. Others disagree, of course, and argue that the amendment also bestows on individuals the right to own a gun, but nowhere in the history of the English language has the phrase "bear arms" ever carried a meaning that does not refer to the military. A man who goes out to hunt deer in the woods does not "bear arms," nor does a woman who fires bullets into paper targets at her local shooting range "bear arms." Only soldiers bear arms, and in the few instances when the issue came before the Supreme Court, the Justices always ruled in favor of the military reading of the text. Then came the 2008 decision in the District of Columbia v. Heller case, when by a narrow five-to-four vote the court reversed historical precedent and embraced the larger interpretation of the Amendment, declaring that "the right to keep and bear arms" in fact applied to individuals as well. Nevertheless, as Justice Antonin Scalia emphasized in his majority opinion, "the right secured by the Second Amendment is not unlimited" and "nothing in our opinion should be taken to cast doubt on longstanding prohibitions on the possession of firearms by felons or the mentally ill, or laws forbidding the carrying of firearms in sensitive places such as schools and government buildings, or laws imposing conditions and qualifications on the commercial sale of arms." A victory for the gun lobby, yes, but not a resounding one,

which leaves us almost precisely where we were before the case was decided, and proves the point, I believe, that it would be folly to think we can settle this issue in the courts.*

Gun control, or "prohibitions on the possession of firearms" (to use Scalia's phrase) have been part of American life since the seventeenth century, with colonial, state, and local governments passing over a thousand laws and ordinances that imposed restrictions on the brandishing of guns, the open carry of guns (New Jersey, 1686, because such conduct inspired "great Fear and Quarrels"), and the carrying of concealed weapons (Kentucky, 1813), enacted bans on sawed-off shotguns, silencers, and machine guns (West Virginia, 1925, soon followed by twenty-seven other states) as well as semi-automatic guns (ten states in the 1920s and 30s). Further laws banned dueling, denied felons the right to own guns, required hunters to obtain licenses and limited hunting to certain weeks of the

* For more on the Heller decision, the judicial theory of "originalism," and illuminating explorations of the Second Amendment and other matters pertaining to guns, see two books of special note: *Gunfight: The Battle over the Right to Bear Arms in America*, by Adam Winkler (2011), and *The Second Amendment: A Biography*, by Michael Waldman (2014). Winkler is a professor of constitutional law at UCLA, and Waldman is the president of the Brennan Center for Justice at NYU School of Law.

year, required the owners of handguns to obtain permits (the New York Sullivan Act, 1911), required gun dealers to obtain licenses (New Hampshire, 1917), levied taxes on guns (Georgia, 1866; Mississippi, 1867), required all guns of any type to be registered by their owners (Montana, 1918), and, in nearly every state across the country, made it illegal to fire a gun in a public place, a school, a church, a house, a train, and anywhere near a road or a bridge.* Go back to the 1870s, and nowhere was the logic of those prohibitions more effective than on the lawless frontier of my TV childhood, which turns out to have been little more than a myth created by the authors of dime novels and the immensely popular extravaganza known as Buffalo Bill's Wild West show, which toured the country for decades, spreading the same sorts of ultraviolent gunslinger caricatures that were later recycled in movies and on television throughout the twentieth century, for the truth was that legendary towns such as Dodge City, Tombstone, and Deadwood, the supposed hot spots and capitals of one-on-one armed showdowns, gang-against-gang Main Street shoot-outs, and gun brawls in rowdy saloons where every other poker player dealt from the bottom of the

* See Robert J. Spitzer, "Gun Law History in the United States and Second Amendment Rights," scholarship.law.duke.edu (2017).

deck, were largely devoid of the nonstop violence presented in classic Westerns. As Winkler points out in his book, from 1877 to 1886 there were a total of fifteen homicides in Dodge City (1.5 per year); in 1881, Tombstone's most violent year on record, five people were killed (three of them in the skirmish at the O.K. Corral); and in Deadwood's most violent year the total was four. The reason for these surprisingly low numbers was strictly enforced gun control regulations. Men were free to carry guns in the wild, but once they entered town, they were compelled to disarm and remain disarmed until they left. Signs were posted around Wichita instructing people to "Leave Your Revolvers at Police Headquarters and Get a Check." In notorious Dodge City, the signs read: "The Carrying of Firearms Strictly Forbidden." In the interests of the common good, the municipal governments of those places had issued ordinances to protect the population from harm and to ward off potential public health crises that would have forced town officials to grapple with ever-mounting piles of permanently dead and/or bullet-punctured bodies. As scholar W. Eugene Hollon put it in his 1974 study, *Frontier Violence*, the Old West was "a far more civilized, more peaceful, and safer place than American society is today."

The first federal law regarding gun control was the National Firearms Act of 1934, which put such a heavy tax and

such onerous conditions on the sale and purchase of machine guns that those deadly, military-style weapons were effectively banned. The proliferation of the tommy gun was a direct result of the rise of criminal gangs and gangsterism in the 1920s, and the principal reason for that rise was another amendment to the Constitution, the eighteenth, which outlawed the sale of intoxicating liquors and ushered in the upside-down, topsy-turvy years of Prohibition. Not all the motives behind the amendment were unsound (the scourge of alcoholism unquestionably destroyed many lives and ruined many families), but most people who drank alcohol were not alcoholics, and in the many centuries since Dionysus had given the world the miracle of wine, that mildly intoxicating liquor had become an integral part of daily life for hundreds of millions, consumed as an accompaniment to meals, as an aid to companionship and conviviality, as a soothing balm to tired, anxious souls, and often as an aphrodisiacal component of erotic desire. By the early twentieth century, with the consumption of wine and beer and various sorts of distilled spirits deeply embedded in almost all human cultures, Americans balked at the restrictions that had been imposed on them and refused to obey the law. The result was a national catastrophe, for not only did the Eighteenth Amendment not stop Americans from drinking, it had the perverse counter-effect of inducing them to drink more, which spawned

an army of bootleggers and the highly profitable business of illegal trafficking in spirits, caused untold numbers of deaths and blindings from bathtub gin and home-concocted vats of wood alcohol, and unleashed such violent turf wars among the booze peddlers that criminals such as Al Capone, Lucky Luciano, Meyer Lansky, and Bugs Moran became national celebrities. Hence the ban on machine guns in 1934, just one year after the passage of the Twenty-first Amendment, which repealed the Eighteenth Amendment and put an end to Prohibition but not, alas, to organized crime—which is still with us a century later and endures as a textbook model of the law of unintended consequences.

I offer Prohibition as an example of what *not to do* in the face of a national crisis. Much as I would like to solve the problem of gun violence, and willing as I would be to accept a ban on the manufacture and sale of all guns, gun owners in this country would not stand for it, and those bans would be no more effective than the ban on alcohol was in 1919, for just as most people who drink alcohol are not alcoholics, the vast majority of people who own guns have no intention of using them to harm or kill other people. But even if those bans were enacted, they would still accomplish nothing. With close to four hundred million guns already among us and a further influx of guns now available through new methods of home manufacture (3D printers and

do-it-yourself assembly kits for ghost guns), any person deter-
mined to obtain a gun would have little trouble finding one. Even
in my home city of New York, where the Sullivan Act is still in
force and all owners of handguns are required to obtain a permit,
the law is easily circumvented, and guns smuggled in by black
market dealers from states with lax gun regulations such as
South Carolina and Virginia can be bought on the street for any-
where between three hundred and a thousand dollars. And just
suppose, for the sake of argument—to stretch the point to the
utmost limit of absurdity—that I was appointed supreme ruler of
the United States for one hour and then stood on a mountaintop
and announced that my one and only act in office would be to buy
back every gun in the country at five times its commercial value
in order to melt them down into farm implements, my words
would be construed as a declaration of war. Before I reached the
bottom of the mountain, I would have been killed a thousand
times over and my body would resemble a hunk of Swiss cheese.

No, forget absolute bans and draconian measures to impose
peace on the embattled. Peace will break out only when both
sides want it, and in order for that to happen, we would first have
to conduct an honest, gut-wrenching examination of who we are
and who we want to be as a people going forward into the future,
which necessarily would have to begin with an honest,
gut-wrenching examination of who we have been in the past. Are

we ready for this long-deferred national moment of truth and reconciliation? Perhaps not today. But if not today, when?

After the country made an error of judgment and enacted the Eighteenth Amendment, we eventually turned around and enacted the Twenty-first Amendment, which undid much of the harm caused by that error—proof that the Constitution is a flexible enough document to allow for the correction of mistakes, which is why most scholars call it a "living document." But not all scholars. As Michael Waldman recounts in his book, Antonin Scalia, the author of the majority opinion in the Heller case, delivered a speech at Princeton University before a crowd of seven hundred people on December 11, 2012. At one point he said: "I have classes of little kids who come to the court, and they recite very proudly what they have been taught, 'The Constitution is a living document.' It isn't a living document. It's dead. Dead, dead, dead!" Three days after that, Waldman reminds us, "a deranged young man walked into Sandy Hook Elementary School in Newtown, Connecticut, and murdered twenty children and six adults."

Covina, California. December 24, 2008.
10 people killed; 3 injured (2 from gunfire).
The killer fled in his car and committed suicide thirty miles from
the site of the shootings. A new structure now sits on the lot
of the destroyed house, which was burned down during the attack.

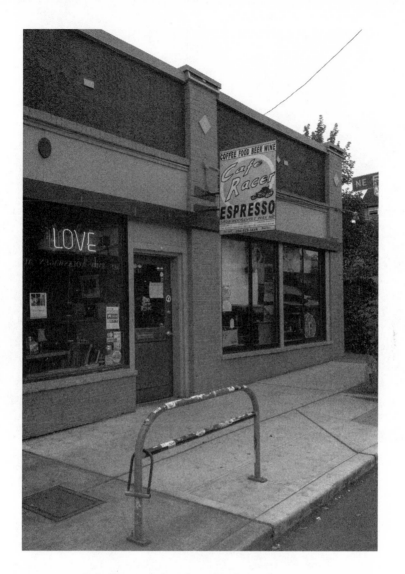

Cafe Racer and parking lot five miles away.
Seattle, Washington. May 30, 2012.
6 people killed; 1 injured.
The café is now closed. There are plans to turn
the building into an internet radio station.

Inland Regional Center and East San Bernardino Avenue.
San Bernardino, California. May 30, 2012.
16 people killed; 24 injured.
The two shooters (a man and a woman) were married to each other.

Bayview Cemetery and JC Kosher supermarket.
Jersey City, New Jersey. December 10, 2019.
6 people killed; 3 injured.
There were two shooters, a man and a woman.

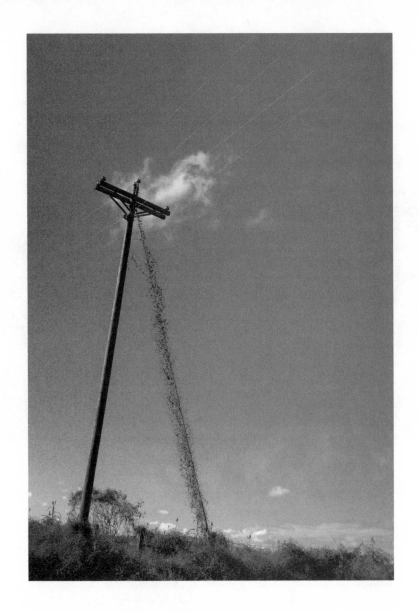

Multiple locations.
Geneva County, Alabama. March 10, 2009.
11 people killed; 6 injured.

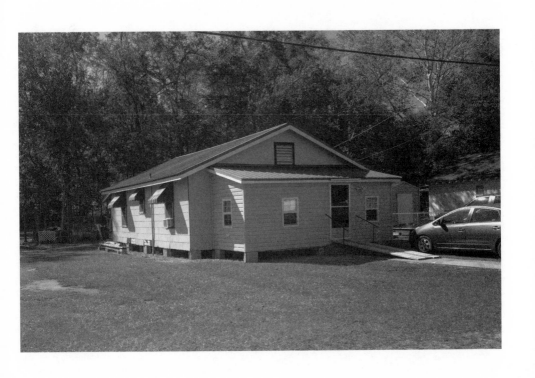

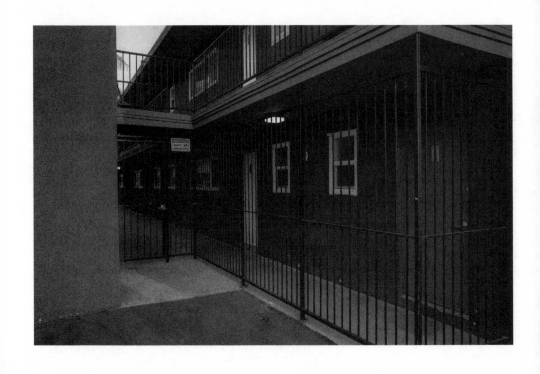

Multiple locations.
Isla Vista, California. May 23, 2014.
7 people killed (3 by stabbing, 4 by gunfire); 14 injured (7 by gunfire, 7 by car).

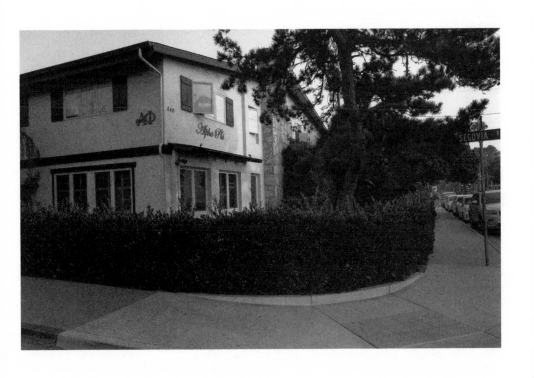

4

One of my good friends is a man named Frank Huyler, a writer who has published poems, novels, and works of nonfiction but is also an emergency room doctor at the University of New Mexico Hospital in Albuquerque, where he has been on the staff for more than twenty years. His two collections of short personal pieces documenting his life in the ER—*The Blood of Strangers* (1999) and *White Hot Light* (2020)—are both masterpieces in my opinion, at once so powerful and so beautiful that I rank him as one of the finest writer-doctors since Chekhov. Early on in my investigations into the grim particulars of American gun violence, Frank and I talked for a couple of hours on the phone as I pumped him with questions about the various measures taken when a gunshot victim turns up in the ER, something that happens a little over a hundred times a year by his estimate, which of course does not reflect the total number of shootings treated at the hospital, since he is not on call every day of the year. From my scribbled, barely legible notes, I can make out the following:

> ambulance—or car with guy slumped in backseat
> ER
> depends on where person is shot
> in leg—misses bone—bullet zips through—little

hole—send home

hits bone—bone shatters, depending on weapon

shotguns—terrible

rifles—terrible—tissue destruction

pistols—like ice picks

belly—hole—must decide quickly about internal
 bleeding

blood pressure—IVs—quick assessment of vital signs

looks stable or unstable—gray/ashen—cut off clothes

look for holes—strange trajectories of bullets—

unclear where they will wind up—

abdomen—operating room—open belly—look for
 hole—

pierce bowel (not looking for bullet)—often leave it in—

hard to find (lodged in a muscle)

surgery—control bleeding—surgically if bowel—
 must repair—

intestinal contents leak into abdomen—cure infections

post-surgery—bowel—colostomy—a few days in hospital

but, if lots of bleeding, can be weeks

chest—bullets can go right through

or lodge—and collapse lung

treatment—chest-tube—like thin garden hose—

stick between ribs

lung like a bag within a bag
chest cavity—2 layers—
punctured—air leaks out between lung and chest—
 collapsing lung—
pneumothorax—sucks out air—lung re-expands
often blood there too—if small or large vessel hit—
 many deaths
face—head—
disfiguring injuries—depending on weapon—
long gun—short arm—
suicides—bullet doesn't hit brain—don't die right away
Head
heavy caliber guns—come in unconscious—
if brain stem functions remain, can survive for a while
top of brain pierced—swelling, bleeding—causes death
head—often suicide attempts—
in most cases drunk
causes of shootings—
1. suicides (side of head, typically)—temple—
 cuts optic nerve—
blind
human skin tough and elastic—
skin can act as net—just under surface
2. criminal shootings—drive-bys—drugs—

rite of passage for young gang members
most spur-of-the-moment—revenge killings—
3. domestic disputes—fights become shootings—
4. families—crimes of passion—often drunk
bars, domestic quarrels—men killing women,
> few in reverse

most victims men

young men mostly

When I asked Frank if he had ever treated a victim or victims of a mass shooting, he said that it had happened to him only once, about ten or twelve years earlier. A man had walked into his ex-wife's office one afternoon bent on killing her, but before he managed to track her down he warmed up by shooting randomly at various workers sitting at their desks. Three people died and several others were wounded. One by one, emergency patients arrived at the hospital, and among the people Frank was called upon to examine was a woman in her late thirties. He didn't tell me how many times she had been shot, but I understood that her condition was precarious, and as she lay on her back looking up at Frank, she said to him in what he called a "calm, clinical voice"—without the slightest trace of fear in it—*I'm going to die*. Then, in the same passionless voice, she gave him her husband's cellphone number, and not long after

that, before she could be wheeled into the operating room for surgery, she was dead.

Mass shootings account for just a small fraction of American gun deaths, but they nevertheless occur with stunning frequency, roughly one per day over the course of any given year. Four is the number generally given to define *mass*, although for some that means four people dead and for others it means four people shot, whether killed or wounded. As with nearly all the one-on-one gun killings across the country, only a small number of mass shootings are reported in the national press. Americans have become so inured to the daily slaughter around them that they can't be bothered to pay attention anymore, even as the numbers continue to mount year after year after year. But then, suddenly, a mass shooting occurs somewhere that stands out from the rest, a bloodbath of such magnitude and horror that the whole of American society is momentarily stopped in its tracks as cameras swoop in to capture images of ravaged, weeping people and reporters dig into the details of the crime and publish stories about the killer and his motives and op-ed writers and television commentators spew forth their opinions to the public. For a brief moment, everyone seems to come together in this lonely, fractured country, but two blinks later the pro-gun and anti-gun camps are squaring off against each other again, and in spite of the outraged cries for reform and action and change,

nothing ever changes, and within a week or two the distracted public turns its attention elsewhere.

These grisly spectacles have occurred often enough in the past two decades to qualify as a new form of American ritual: bloodshed and grief transformed into a series of ghoulish entertainments that time and again plant us in front of our television sets as we absorb the grim-faced accounts of the newest nightmare and bemoan what has happened to our beloved America. Meanwhile, the networks boost their ratings and increase their profits by reversing the old huckster's jingle, "more bang for your buck," into "more bucks from the bang." It is enough to turn the most hopeful idealist into a full-bore cynic.

Most of these mass murders are committed by solitary young men, occasionally by older men in their early middle age, rarely, very rarely (almost never) by women, and as with the furious ex-husband in Albuquerque, they are generally hatched in a dark inner sanctum of personal grievance, where they go on festering for months, even years, and then metastasize into a universal hatred that pushes the shooter into killing anyone even remotely connected to his primary target. That is what distinguishes mass grievance murders from their one-on-one counterparts—the gunman's willingness to turn his weapon on strangers and mow them down for no other reason than the satisfaction of killing them—which is what most people find so

difficult to understand, whether we are pro-gun or anti-gun or somewhere between the two. Why on earth would a man want to kill people he doesn't know, especially people who have never done him any harm and most likely would help him off the ground if they saw him fall or reach into their pocket and give him a dollar if he told them he was hungry? Horrible and shocking as all one-on-one grievance murders are, they do not plunge us into the same depth of confusion, for we all understand anger and even rage, and we can all imagine ourselves being driven over the edge of reason into temporary madness and then going after a person we believe has wronged us, as my grandmother did when she shot and killed my grandfather in the kitchen of her house in Kenosha. Unforgivable, yes, but not incomprehensible.

Also not incomprehensible is the contract killer who earns his living by murdering strangers or the young kid from a rough urban neighborhood who knows his life will be under constant threat if he doesn't join a local gang and therefore goes out into the streets one afternoon and fires a bullet into an anonymous passerby to prove he has the guts to be embraced by the clan. No one in his or her right mind would applaud these instances of murder, but at least we understand them. What we don't understand is the arbitrariness of random killing, and each time another mass shooting claims national attention, all of us begin to feel more vulnerable, for if that old person or that young person or that small child can be shot and

killed for no reason, why couldn't it happen to my child or to me? Fear takes hold of us, and fear is a poison that corrupts our ability to think, and when we can no longer think, our decisions are given over to the forces of blind, blundering emotion.

Another thing that distinguishes mass murders from other kinds of murder is the high degree of planning that goes into mounting one of these attacks. Weeks and often months of preparation are required before the killer is ready to pounce. Spur-of-the-moment impulse is off the table; the furious, hot-headed eruptions that precede most fatal bar fights and road-rage killings do not factor into the plotting of mass murders, and contrary to what one might expect, most of these killers go about their business calmly and methodically, with no shouts or denunciations or outward displays of feeling, as if they had entered a zone beyond what we would call normal conscious life, a place where the world is already dead to them and they are dead to themselves. The point is to turn yourself into a killing machine. To that end, these killers choose their weapons carefully, often arming themselves with an assortment of long guns and handguns, and in some cases they arrive at the scene fully girded in body armor. In almost all cases, the weapons and ammunition and armor have been bought through perfectly legal means.

Family grievances, spousal grievances, sexual grievances, workplace grievances, institutional grievances, political

grievances, racial and ethnic grievances (hate crimes), and, as the epidemic of mass shootings continues to spread, the ambition on the part of many of the youngest killers to surpass the death tolls achieved by their predecessors, to break the record and thereby win fame and everlasting outlaw glory as the greatest mass killer in American history. Social media sites swarm with the braggadocio of these would-be destroyers as they prepare themselves to carry out their versions of the armed massacre in a school, a college, or a church, and to read through their communications is to understand that the annihilation of strangers has been turned into both a competitive sport and a sinister new variant of contemporary performance art. It is America's latest gift to the world, a psychopathic footnote to such previous wonders as the incandescent lightbulb, the telephone, basketball, jazz, and the vaccine against polio. Our friends from distant continents look on in perplexity and horror, no less appalled than we are when we read about the genital mutilation of adolescent girls or the practice of stoning women to death when their husbands have accused them of infidelity.

What strikes me as remarkable is that any reasonably attentive American over the age of twenty-five will have no trouble recalling details from a long list of mass shootings that have occurred over the past ten years, the unhinged attacks on elementary schools, high schools, and colleges, for example, such as the 2012

killing of twenty small children and six teachers and staff members at Sandy Hook Elementary School in Newtown, Connecticut, or the seven dead and fourteen wounded in the 2014 gun-knife-car rampage within meters of the UC Santa Barbara campus in Isla Vista, California, or the fifteen-year-old freshman who five months later killed four of his closest friends and then himself in the cafeteria at Marysville-Pilchuck High School in Marysville, Washington, or the nine wounded and ten killed in 2015 at Umpqua Community College in Roseburg, Oregon, or the 2018 bloodbath at Marjory Stoneman Douglas High School in Parkland, Florida, that left seventeen wounded and seventeen dead, and, in the first and last of these cases, the added blows delivered to the suffering families of the victims when an army of conspiracy-mongers from the far right jumped out of the shadows and began spreading false stories that the widely covered and thoroughly documented Sandy Hook and Parkland massacres were in fact nothing more than hoaxes perpetrated by so-called crisis actors. Within hours of the shootings, one form of American madness had given way to another, and as with the Holocaust deniers before them, no amount of contravening evidence has budged the hoaxers from their cruel, cynical assertions.

In all, there have been two hundred and twenty-eight episodes of gun violence in schools and colleges across the country in the past ten years. Thirty of them have been large enough

to qualify as mass shootings, and among the examples I have just given it is striking to look at the personal histories and motives of the shooters and discover how many traits they had in common. To begin with, all of them were young—fifteen, nineteen, twenty, twenty-two, twenty-six—and all of them had shown clear signs of mental and emotional disturbance by late childhood or early adolescence. The oldest four were obsessed with guns, were mostly friendless and hostile to others at school, and bore smoldering grudges against the people they felt were responsible for their walled-off, impoverished lives. The single word that runs through all their stories is *loneliness*, unbearable, mind-crushing loneliness, which is the same loneliness that drives millions of other Americans to seek comfort in various forms of obliteration—too many drugs, too much alcohol, and obsessive fugues into the labyrinthine pathways of the Internet. Lives of slow self-destruction that year after year result in tens of thousands of "deaths of despair," a new term for a new kind of American misery, and at the far end of the misery spectrum stand the killers, the ones who opt to destroy themselves by destroying others, for the truth is that every person who sets out to kill large numbers of random, unknown people is also plotting his own suicide.

The Isla Vista shooter left behind a one-hundred-thousand-word account of his life that is notable for its precisely

articulated resentments and ever-deepening misogynistic rage against the pretty sorority girls who continually snubbed him, and in a much shorter text entitled "My Story," the Umpqua killer serves up a document that is at once lucid, self-pitying, and grotesque:

> I have always been the most hated person in the world. . . . My whole life has been one lonely enterprise. One loss after another. And here I am, 26, with no friends, no job, no girlfriend, a virgin. I long ago realized that society likes to deny people like me these things. People who are elite, people who stand with the gods. People like [a list follows of the young men responsible for the massacres at Isla Vista, Columbine, Sandy Hook, and Virginia Tech].
>
> Just like me those people were denied everything they deserved, everything they wanted. Though we may have been born bad, society left us no recourse, no way to be good. I have been forced to align myself with demonic forces. What was once an involuntary relationship has now become an alignment, a service. I now serve the demonic Hierarchy. When I die I will become one of them. A demon. And I will return to kill again and again. I will possess another and you will know my work by my sign, the penta-gram will fly again. . . . My success in Hell is assured. . . .

And just like me, there will be others, like Ted Bundy said, we are your sons, your brothers, we are everywhere. My advice to others like me is to buy a gun and start killing people. . . .

I have been interested in mass shootings for years. I noticed where they always go wrong is they don't work fast enough and their death toll is not anywhere near where it should be. They shoot wildly instead of targeted blasts. They also don't take on the cops. Why kill other people but you won't take out the cops. . . .

Q. Are you mentally ill?

A. No I'm not. Just because I'm in communion with the Dark Forces doesn't mean I'm crazy.

Beyond the schools and the horrific murders of small children, large children, and young adults, along with the free fall into chasms of unremitting grief for hundreds, thousands, uncountable numbers of mothers, fathers, brothers, sisters, cousins, aunts, uncles, grandparents, and friends, there have been the shootings in public places, both indoors and outdoors, both at night and during the day, and here again the litany from the past ten years will be known in advance by nearly everyone who reads these pages. The 2011 assassination attempt on congresswoman Gabrielle Giffords as she was delivering a speech in the

parking lot of a supermarket just outside Tucson, Arizona, carried out by a twenty-two-year-old man armed with a Glock 19 semi-automatic pistol who fired haphazardly into the assembled crowd, leaving fifteen wounded and six dead (among them a federal judge and a nine-year-old girl), and although the assassination attempt failed, Giffords, who was shot in the head at point-blank range and yet unaccountably pulled through, will be gravely impaired for the rest of her life. The 2012 massacre by a twenty-four-year-old doctoral student in neuroscience at the Century 16 multiplex in Aurora, Colorado, as four hundred people were watching a midnight screening of the latest Batman movie in Theater 9. Seventy people were wounded or injured and twelve were killed, among them a six-year-old girl, whose pregnant mother suffered massive wounds to her chest and was permanently paralyzed. The week after the attack, she miscarried and lost her unborn child. The 2015 assault on a Planned Parenthood clinic in Colorado Springs by a fifty-seven-year-old self-proclaimed "warrior for babies" that wounded nine people and killed three. The 2016 nightmare in Orlando, Florida, when a twenty-nine-year-old man murdered forty-nine people and wounded more than fifty others before killing himself on "Latin Night" at the gay nightclub, Pulse. At the time, it was the deadliest mass shooting in American history, but just fifteen months later those numbers were eclipsed by a sixty-four-year-old man at

the Mandalay Bay Resort and Casino in Las Vegas who killed sixty people, shot and wounded 441 others, and then killed himself. An additional 456 people were injured in the ensuing chaos as the attacker fired from the window of a thirty-second-floor room overlooking a large, fenced-in public space where 22,000 people had gathered for the annual Route 91 Harvest Country Music Festival. The following year, 2018, a twenty-eight-year-old Marine veteran shot into a crowd of 260 people at the Borderline Bar and Grill in Thousand Oaks, California, a country-western music hangout frequented by students from several colleges in the area, injuring sixteen people and killing thirteen, among them a twenty-seven-year-old Navy veteran who had survived the attack in Las Vegas the previous year. He was just one of about fifty or sixty people who were present at both shootings. According to the *New York Times* (11/8/18), "The Border-line . . . had become a place of solace for dozens of survivors of the Vegas massacre to come together for music, for healing, and for remembering." They called themselves the Route 91 Family. Then came the back-to-back mass shootings on August third and fourth, 2019, the first one at a Walmart in El Paso, Texas, when a twenty-one-year-old white nationalist targeted Mexicans and Mexican-Americans in what the FBI judged to be both an act of domestic terrorism and a hate crime. His AK-47-style rifle killed twenty-three and wounded twenty-three others. Just sixteen

hours later, a twenty-four-year-old man attacked the patrons of the Ned Peppers Bar in Dayton, Ohio, with an AR-15-style pistol. Within the space of thirty-two seconds he killed nine people and injured twenty-seven before he himself was shot and killed by a policeman who happened to be at the bar. Whether by accident or design, one of his victims turned out to be his twenty-two-year-old sister.

Eight examples culled from a horde of possibilities, and yet merely to enumerate them in the dry, flat language of a forensics report is enough to make your head spin and your knees buckle at the sheer amplitude of so much senseless carnage. Six young men in their twenties and two others at the more advanced ages of fifty-seven and sixty-four. The reasons behind what they did vary from case to case, and with the two mega-crimes committed in Orlando and Las Vegas, the reasons escape all understanding.

The Arizona shooter who tried to kill Gabby Giffords belonged to the vast legion of lost American boys, a psychologically damaged misfit who was expelled from school for persistent episodes of disruptive behavior and was incapable of holding down a job, whereas the equally damaged Aurora multiplex shooter was a Phi Beta Kappa honors student who started dreaming of killing large numbers of strangers when he was just eleven or twelve and planned his attack in painstaking detail, working out his ideas so precisely, with such elaborate preparations

for any and all contingencies, that when he finally launched his operation on the night of July 20, 2012, he pulled it off exactly as he hoped he would. Dressed in black, with a gas mask over his face and a ballistic helmet on his head, he stood before the movie screen with his body armored in a load-bearing vest, bulletproof leggings, a bulletproof throat protector, a groin protector, tactical gloves, and a set of headphones clamped over his ears pumping in loud techno music to block out any potential sounds from the audience. One gapes at the wonder of those headphones: A man is about to toss two canisters of tear gas into a crowd of four hundred people and then open fire on them with a shotgun, a semi-automatic rifle, and a handgun, and yet his nerves are so delicately strung that he cannot bear to listen to the clamor and the screams those actions will inevitably provoke. He surrendered to law enforcement officials without putting up a fight, and after he was deemed mentally fit to stand trial, he was sentenced to twelve life terms and an additional 3,318 years for acts of attempted murder.

There is speculation that the ex-Marine shooter in Thousand Oaks was suffering from acute PTSD brought on by his battle experiences in Afghanistan. The Planned Parenthood shooter in Colorado Springs was "a religious fanatic obsessed with the end of the world" (according to his ex-wife) and was judged incompetent to stand trial. The Dayton shooter had a long history of making

violent threats and as far back as high school had drawn up lists of people he wanted to rape and kill. In the year before his attack at the Ned Peppers Bar, he sang vocals for a pornogrind band called Menstrual Munchies, and, according to the *Washington Post* (8/5/19), told his high school girlfriend that he had "visual and auditory hallucinations and was afraid of developing schizophrenia." The clear-minded shooter at the Walmart in El Paso, on the other hand, had no doubts about the purpose of his mission. In a manifesto entitled "The Inconvenient Truth," he wrote: "This attack is a response to the Hispanic Invasion of Texas. . . . Hispanics will take control of the local and state government of my beloved Texas, changing policy to better suit their needs. They will turn Texas into an instrument of a political coup which will hasten the destruction of our country."

The Pulse nightclub killer in Orlando, however, left behind no more than the murkiest traces. An American-born Muslim from an Afghan family, he claimed to be acting in protest against American airstrikes in Syria and Iraq, but at no point before then had he ever been involved with or even remotely connected to an Islamist political organization, and while others claimed that he was a closeted gay man who had been to the club at least a dozen times in the past, there is little hard evidence to support that claim. As for the Las Vegas shooter, the only verifiable facts that have surfaced about him are that he was a twice-married and

twice-divorced retired businessman, a high-stakes gambler who was a known figure in various Las Vegas casinos, a heavy drinker, and the son of a bank robber who had been on the FBI's most wanted list between 1969 and 1977. A relevant detail, perhaps, or else nothing more than a biographical curiosity. Take your pick. All we know for certain is that he accumulated an immense arsenal of weapons in the months prior to the attack and that in the days leading up to the massacre he deposited a total of twenty-two suitcases in his hotel suite—containing fourteen AR-15 rifles equipped with bump stocks and 100-round magazines, eight AR-10-type rifles, a bolt-action rifle, and a revolver, which was the weapon he used to kill himself after the spree was done. At no point during his preparations did he tell anyone about his plans, and he left behind no written statement to account for his actions. We therefore know nothing about them and never will. The worst mass shooting in American history is a blank in the cosmos, a silence.

Two days ago, I received the latest book published by my old college friend Hilton Obenzinger, a collection of poems entitled *Witness: 2017–2020*. One of the poems addresses the question of gun violence in America, and submerged as I have been over these past many months in the gunk and gore and horror of that violence, the stinging, satirical absurdities coursing through that poem hit me with a thunderbolt of recognition. Nothing I have

read since I started writing this essay has so clearly expressed the revulsion I feel and which millions of others also feel whenever we look closely at the monstrosities we live with from day to day in our battered, beautiful, embittered country. Dated November 6, 2017, the poem is entitled "Let's Shoot." I quote it in full.

Let's go to church and shoot
Let's go to the movies and shoot
Let's go to the music festival
Let's go to the supermarket
Let's go to the school
Let's go to the aquarium and shoot out the glass
And have people drown while we shoot them
And don't forget to shoot the fish
Let's go to the museum and shoot Art
And then shoot the people looking at Picasso
Let's shoot Picasso
He's dead so let's go to the cemetery and shoot the dead
Lets go to the Halls of Justice and shoot all the judges
Let's go to the NRA HQ and shoot everyone
Let's go to the moon and shoot Earth
Let's get drunk and shoot
Let's pray and shoot
Let's go to the hospital and shoot the sick

Let's get naked and shoot

Let's shoot naked people

Let's get an AR-15 and shoot people we hate

Let's shoot people we love

Let's never run out of bullets

Let's never run out of long guns automatics

 machine guns

Let's get a truckload of grenade launchers

If only we had tanks and missiles

Let's shoot while the shooting lasts

So much to shoot and so little time

Let's shoot the small quiet wind

That blows through our hearts

And kill it good

Let's go to church and shoot. Houses of worship have also
been invaded by mass killers in recent years, and with only one
exception all of those attacks have been carried out by lone-
wolf, white-power bigots intent on purifying the country of con-
tamination by dark-skinned Others or non-Christian Others,
principally Muslims and Jews. Hence the 2012 assault on a
Sikh temple in Oak Creek, Wisconsin, by a forty-year-old neo-
Nazi and skinhead-band backup vocalist that left seven dead
and three wounded and then eight dead after the killer killed

himself. In all likelihood, he had confused the turban-wearing Sikhs with Muslims and had gunned down the wrong group of strangers. Hence the 2015 murders of nine Black people by a twenty-one-year-old white supremacist at the historic Emanuel African Methodist Episcopal Church in Charleston, South Carolina. Among the dead was the senior pastor, who also happened to be a prominent state senator and a leading light of the Black community. Hence the 2018 slaughter of eleven Jews and the wounding of six others at the Tree of Life synagogue in Pittsburgh by a forty-six-year-old white nationalist who held Jewish organizations responsible for funding the Central American caravans that bring in "invaders who kill our people."

Three examples of what can happen when hatred is stoked in the hothouse echo chambers of social media sites and then further amplified by easy access to firearms, ending in the delusional folly that the deaths of nine Black people or eleven Jews or seven Muslims who aren't even Muslims will rid white Christian society of its polluting elements and make the vast American sky breathable again. Such is the pattern that emerges from all three of these cases, and then there is the exception, the one church shooting that was not motivated by ethnic or racial animus or irrational fear of the Other and yet takes us straight into the heart of the fifty-year battle that has been fought in this country over the question of guns, that is, the right to own a gun versus the social imperative to

stem the violence caused by guns, and whether the NRA dictum formulated by its chief spokesman after the Sandy Hook killings in 2012 that "The only thing that stops a bad guy with a gun is a good guy with a gun" makes any sense.

The case I am referring to is the mass shooting at the First Baptist Church in Sutherland Springs, Texas, on November 5, 2017, that killed twenty-five people—one of them a pregnant woman—and wounded twenty-two others. The killer was a brutal, hotheaded, out-of-control twenty-six-year-old fuckup who had been suspended from high school seven times, had lied on his application to the Air Force in 2009, had beaten, threatened, and terrorized his first wife by holding a loaded gun to her head, had repeatedly struck and slapped his eleven-month-old stepson, who landed in the hospital with a fractured skull after one of the assaults, leading to the killer's arrest and a one-year term in a military prison along with an eventual bad conduct discharge from the Air Force, which failed to report his offenses to the federal authorities and therefore kept him off the list that would have barred him from buying a gun. After he and his first wife divorced, he was investigated for sexual assault, rape, and physical assault of a girlfriend, although the Sheriff's Office of Comal County, Texas, chose not to press charges, and then, after marrying for a second time and moving to Colorado, he was fined for beating his underfed dog in public, bragged to a former Air

97

Force colleague on Facebook that he routinely bought dogs and other animals to use for target practice and that he greatly admired the young man responsible for the AME church shooting in Charleston. After returning to Texas with his second wife, who soon became his estranged second wife, he began sending threatening emails to his mother-in-law, who for some unknown reason or reasons had become the object of the killer's hatred, a hatred so large and so intense that a moment came when he resolved to kill her, and because he knew she attended services at the Sutherland Springs Baptist Church every Sunday, he decided to kill her there—along with everyone else who happened to be present. As it turned out, neither his mother-in-law nor his estranged second wife attended services that morning, but when the killer showed up at eleven o'clock on the appointed day with a fully loaded AR-556 semi-automatic rifle, he didn't know that and assumed his mother-in-law would be inside the church. After pulling up in front and sitting behind the wheel of his Ford SUV for about twenty minutes, he roused himself to action and stepped out of the car dressed in black tactical gear, a bulletproof vest, and a black mask emblazoned with a white skull on it. I will not recount the details of what he did next or dwell on how he went about the business of slaughtering twenty-five people and wounding twenty-two others but will merely point out that many of the dead and wounded were children—and that

many of those were young children of three and four and five. The youngest of those young was eighteen months old.

He wanted to kill everyone in the church but didn't, and therein lies the rest of the story of what happened that day and accounts for why I have chosen to fix my attention on this particular crime more than any of the others. Because this is the only case from recent years in which a bad man with a gun was stopped by a good man with a gun. Not soon enough to prevent a massacre, but without the intervention of that good man, many more people would have been killed.

He was a fifty-six-year-old plumber who lived with his wife and one of his three adult children in a house across the street from the church. His family had been in Sutherland Springs for seven generations, and in that small, hardscrabble farming community of six hundred people just thirty-plus miles from San Antonio, this stoutly built man with his white beard and warmhearted, unassuming manner was a significant someone, an admired, even beloved friend and neighbor of everyone who knew him. Sutherland Springs was his patch of ground, and as it was for nearly all the people around him, he had been brought up to follow the teachings of Christ and to master the art of handling a gun. His father had taught him to shoot when he was five years old—aiming at Coke cans in the backyard with a bolt-action .22 rifle—and, as writer Michael J. Mooney tells us in an excellent

piece for *Texas Monthly* ("The Hero's Burden," November 2018), he was later drawn to competitive shooting and "could hit the string of a moving balloon from a hundred yards away." This was a man who believed in guns, who respected guns, and knew how to use them with crackshot precision. He also knew how dangerous they were, and as a conscientious gun owner, he took special care to protect others by storing his collection of rifles and handguns in a locked safe.

On the Sunday morning in question, he was taking it easy, resting up for what promised to be an eventful, taxing week at his job with the University Hospital in San Antonio. When the killer began his attack in the church, the good man was fast asleep in his bed, but at eleven-thirty his daughter came into the room to tell him that she thought she heard gunfire somewhere in the vicinity. He sat up and listened, but the sounds were so muffled in that part of the house that they came across as little more than faint taps on the window. He rolled out of bed, climbed into a pair of jeans, walked into the living room at the front of the house, and finally understood that yes, a gun was indeed being fired somewhere. Fully awake and alert now, he hurried off to the back room where he stored his guns, opened the safe, and took out one of his AR-15s, which he rapidly loaded with a number of rounds. By then, his daughter had already left the house in her car and come back with the news that the gunfire was coming

from the church. The man immediately called his wife—who was visiting one of their married daughters—to tell her what was happening across the street, and when she started begging him not to go over there, he hung up on her and, without bothering to put on a pair of shoes, bolted toward the front door. His daughter followed him, but thinking quickly in order to protect her from potential harm, he asked her to go back inside and load another magazine for him. Then he went out on his own, crossing the street and walking the hundred and fifty yards to the church as the sounds of the gunshots blasting inside grew louder and louder. An appalling catastrophe was in progress, and the good man with the rifle in his hand who knew most if not all of the members of that church spontaneously yelled out a single word at the top of his lungs: "Hey!" Tactically, it was the wrong move—betraying his position to the shooter—but as survivors within the church later told him, the killer stopped shooting when he heard the power and ferocity burning in that voice, and then, within seconds, he put down his rifle and headed for the front door. The spell had been broken. In his article, Mooney reports that the brave plumber is convinced that the Holy Spirit was speaking through him "to call the demon out of the church."

Then came the shoot-out. The killer rushed outside in his black body armor and visored helmet with a pistol in his hand as the Good Samaritan scrambled for cover behind a Dodge truck

parked in front of the house next door. The killer fired three times—once into the truck, once into a nearby car, and once into the house—three misses. The plumber fired four times in two pairs of two shots each, and every one of his bullets hit its mark. The first two into the front of the bulletproof vest, which caused large contusions on the killer's torso, and then, as the killer started running toward his SUV—about twenty yards from the Dodge—the second two shots into his body, one in the leg and the other in an unprotected area of exposed skin between the front and back halves of the bulletproof vest just under the man's arm. Still standing, still running, the killer jumped into his van, slammed the door shut, and fired twice more through the window on his left—both misses. Aiming for the man's head, the plumber then shattered the driver's side window with his fifth bullet, and as the killer stepped on the gas and began speeding away, his barefooted opponent ran into the street, lifted his rifle for the last time, and shot out the glass in the rear window with the sixth bullet, which was later found to have lodged somewhere near one of the driver's shoulder blades.

First the shoot-out, and then, by some odd twist of happenstance, the high-speed car chase that followed, for on that day of days circumstances saw to it that another Dodge truck should have been waiting at a stop sign not far from the church. Inside was a twenty-seven-year-old man who had driven to town that

morning to see his girlfriend, and as he eased to a halt in front of the traffic sign, he had heard the stuttering din of rifle fire coming from the church and had called 911. The good man rushed over to the truck and shouted, "That guy just shot up the church. We need to stop him." A moment later, he heard the sound of the doors unlocking, climbed in next to the driver, and the two of them took off in pursuit of the killer, hitting speeds of over ninety miles an hour as they barreled north on the two-lane blacktop that wound through the Texas countryside. The young man kept the 911 dispatcher informed of their position throughout the seven- or eight-mile journey, and in the other car the killer was on his phone as well, first with his estranged wife and then with his parents, openly confessing to what he had done in the church and again and again repeating how sorry he was, how terribly, terribly sorry he was. He closed off by telling them that he was badly wounded and didn't think he was "going to make it." Eventually, he lost control of his van, crashed into a stop sign, careened over a bar ditch, and came to a stop about ten yards into an adjacent field. By the time his pursuers caught up with him, he had fired a bullet into his head and put an end to his short, ugly life.

The second part of the story is a complex, multilayered narrative of one man's actions and his own response to those actions combined with a vast network of external forces

generated by politics, the media, and the amorphous specter called "public opinion" that quickly began to interact with the man's actions and responses to those actions until the man himself was turned into the symbol of a national cause, even as he struggled to maintain the integrity of his private selfhood. Complex, yes, but also moving because of who that man is. In the aftermath of the bloodshed on the day of the killings, he was obliged to give statements to seven different local, state, and federal law enforcement agencies. After telling his story once too often, he broke down and cried, and following that first crying fit, Mooney reports, "he remembers crying more the first week after the shooting than he had the rest of his life combined." Some months later, he told Mooney: "We aren't designed to take the life of another person. It damages us. It changes us." Or, as he put it in one of the first interviews he gave: "I'm having all kinds of issues. I can't put my finger on what my feelings are."

Even on the day of the killings, when people were already beginning to call him a hero, he instinctively pushed back against that kind of inflated talk. On November sixth, the *New York Times* quoted some of the remarks he made to a local television station: "I'm no hero, I am not. I think my God, my Lord protected me and gave me the skills to do what needed to be done. I just wish I could have gotten there faster."

What makes this man so admirable is the solidity of his character, the foursquare, feet-on-the-ground sense of who he is and where and how he stands in relation to others, for not only is he thoughtful and articulate, he is honest, which means that he has the wisdom to understand that he is not some larger-than-life soldier in the eternal war against Evil but a simple man who did what he could under difficult, dangerous circumstances. And still he goes on tormenting himself with the thought of how many more lives could have been saved if only he had made it to the church a mere fifteen seconds earlier. The less than good man gloats over what he has accomplished. The good man eats himself alive over what he has failed to do, even when and especially when he has accomplished more than anyone else would have thought possible.

Almost immediately, the press came swooping down on him as a battalion of journalists camped out on the front lawn of his house, clamoring for interviews, photographs, and exclusive inside stories, and after the reporters had turned him into the most celebrated Texan of the moment and the local police had finally shooed them away, the politicians were the next to come knocking, and one by one the hero from Sutherland Springs met his congressman, the governor of Texas, both of the state's US senators, and the vice president, all of them Second Amendment champions and stalwarts of the NRA, and before long he was

introduced to the president himself, number forty-five, who had been in office for less than a year at that point, and because the shoot-out and the car chase had transformed this man into the embodiment of the many virtues embedded in NRA policy, he was invited to attend the president's first State of the Union address, where he would be presented to the nation as a shining exemplar of American bravery and goodness, and so the sensitive hero and his loyal wife and his large family were flown to Washington and put up in a block of suites at the Omni Hotel where, as Mooney notes, he ordered room service for the first time in his life.

It is hard not to feel some contempt for politicians who exploit the honorable deeds of others to promote their own standing with the public, but here, too, the situation was inordinately complex, for the object of the politicians' praise was in fact a longstanding member of the NRA himself, and when asked to appear in a commercial for the organization, the good man willingly accepted, and when asked to address the annual NRA convention in Dallas some months later, he accepted that invitation as well. I have watched his speech on video and found it both effective and touching in its sincerity, but as the crowd of nine thousand cheered his remarks, I kept thinking back to what he himself had said after his own experience of shooting at another person for the first time: "We aren't designed to take the

life of another person. It damages us. It changes us." And yet he embraces the NRA's position that Americans have the right to arm themselves against the murderous intentions of others. In the light of what happened in Sutherland Springs, the argument seems to make sense and sounds quite persuasive, but once you stop and think about it a little more, you begin to understand that this case is an exceptional one, so exceptional as to be a stand-alone event that does not validate the NRA's position but in fact undermines it—for the simple reason that most if not all other shootings are far more ambiguous and cannot be compared to the stark good-man-versus-bad-man confrontation that occurred in Texas on that bloody Sunday morning. Think back to 1984 and the highly publicized case of Bernhard Goetz, the "Subway Vigilante" from New York who shot four unarmed Black teen-agers out of the fear that they were about to attack and rob him, or else to the 2012 case of Trayvon Martin, an unarmed, seven-teen-year-old Black high school student who was shot and killed by twenty-eight-year-old George Zimmerman because he looked "suspicious." Both of those shootings were motivated by fear, and whether real or imagined, fear is not a legitimate justification for firing a gun at another person. Not every gun owner is as sane or self-possessed as the plumber from Sutherland Springs, after all, and if, as the NRA argues, law-abiding Americans should be and must be armed to protect themselves against the lawbreakers

who threaten our safety, vast numbers of fearful, often irrational people will be empowered to make split-second decisions that will inevitably lead to more killings of unarmed strangers. To put a gun in everyone's hand would turn the United States into a country of soldiers and thrust us back to the early colonial days when every citizen was a musket-bearing warrior and did lifetime service in the local militia. Is that what we want from America today—the right to live in a society of permanent armed struggle? If the problem is too many bad men with guns, would it not be wiser to take those guns away from them rather than arm the so-called good men, who in many if not most instances are considerably less than good, and thereby eliminate the problem altogether, for if the bad men had no guns, why would the good men need them?

As my mother used to say to me whenever I spun off into one of my wild, passionate speculations about how to improve the world: "Dream on, Paul."

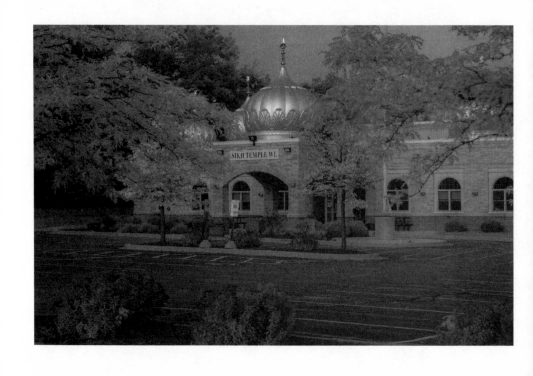

Sikh Temple of Wisconsin.
Oak Creek, Wisconsin. August 5, 2012.
8 people killed; 3 injured.

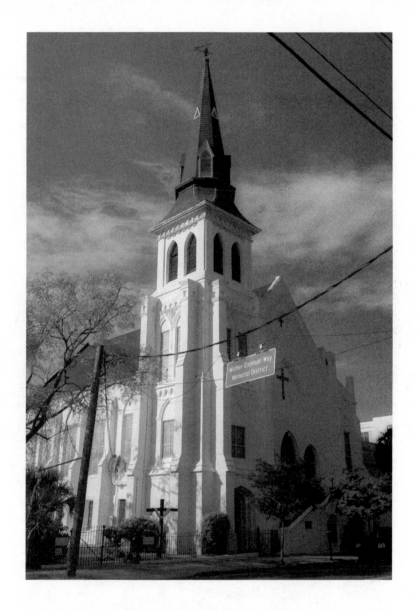

Emanuel African Methodist Episcopal Church.
Charleston, South Carolina. June 17, 2015.
9 people killed; 1 injured.

Tree of Life synagogue.
Pittsburgh, Pennsylvania. October 27, 2018.
11 people killed; 7 injured.
The synagogue remains closed.
Plans have been formed to rebuild the site.

First Baptist Church.
Sutherland Springs, Texas. November 5, 2017.
26 people killed; 22 injured.
The church has been closed for religious services since the day of the shootings.
The sanctuary has been turned into a memorial for the victims.

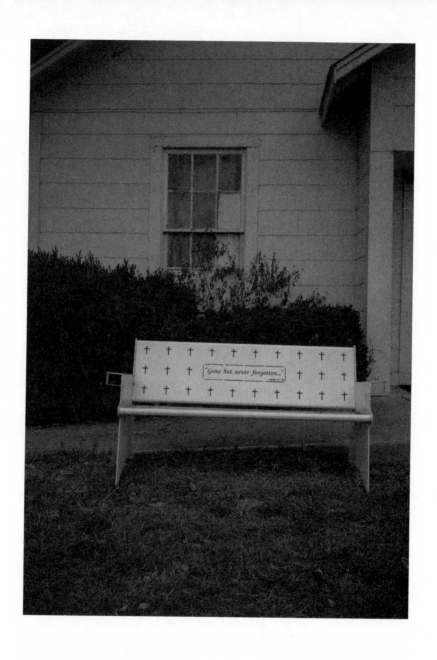

5

It is almost certain that the gun rights movement as it exists today would not have been born without the Black Panthers. At the same time, it is also almost certain that the so-called culture wars of the present moment would not have begun if there had never been a Civil Rights movement or the political and social agitations of the 1960s. The Vietnam War divided the country for years, splitting the population into liberal and conservative camps, with left-wing and right-wing extremists on either side of the spectrum, and although the progressive forces received the bulk of attention from the press at the time, the pushback forces were diligently working in the shadows and ultimately prevailed. Just as the South lost the Civil War on the battlefield but won it in the courts after Reconstruction ended, the reconfigured Republican Party (bulked up by the addition of former Democrats from the South), has not only won the battle of ideas about who we are and who we should be as a nation but has also won most of the presidential elections since 1968, and even when Democrats have won (think Jimmy Carter and Bill Clinton), they have followed the rightward drift of the country and have not pushed hard for the kinds of domestic reforms promoted by Roosevelt and Johnson. Add in the vast changes to the American and world economies since the early seventies that have been steered by the principles

of the new, throwback capitalist ideology of neoliberalism—the deregulation of most industries, the destruction of labor unions, and a blind faith in the market to solve all problems—which has increased the gap between rich and poor to distances not seen since the Gilded Age, and then factor in the notion spread by Ronald Reagan that government is not the solution to our problems but the problem itself (which, in a democracy of "we the people," would mean that we ourselves are the problem), and a nameless, formless cloud of discontent has slowly seeped into every corner of society. The crowning touch came when Barack Obama was elected president in 2008, causing vast numbers of Americans to recoil in horror at the symbolic outrage of seeing a Black Man occupy the White House, and before anyone could blink or pause to take a breath, the Tea Party sprang up and crushed the Democrats in the midterm elections and then continued to crush them even after Obama won a second term, rendering his administration powerless to pass any significant legislation during the last six years he was in office. His election also instigated the Birther Movement, which was the work of a loudmouthed huckster millionaire from New York, and by repeating his lie over and over again in spite of the evidence against him, that weirdly coiffed figure eventually persuaded close to forty percent of Americans to fall for the scam. By using those same tactics in 2016, he managed to get himself elected president, which provoked something akin

to a collective nervous breakdown among the American people for the next four years and nearly wrecked the country, and even though he was voted out of office in November 2020, one mustn't discount the possibility that he and his followers might find a way to wreck it still. Through all these fifty-plus years of national conflict, guns have remained a touchstone issue, the central metaphor for everything that continues to divide us and, as the post-election battles rage on, now threatens to tear us to pieces and put an end to the American Experiment.

On May 2, 1967, thirty members of the Black Panther Party entered the state Capitol building in Sacramento to protest a gun control bill that had been put forward by Republican members of the legislature, and although every one of those twenty-four young men and six young women was armed—with loaded .357 Magnums, 12-gauge shotguns, and .45-caliber pistols—they were not breaking the law and in fact were well within their rights to do what they were doing, since there was no ban in California that prevented people from carrying loaded guns in public—as long as the guns were visible and not pointed at anyone in a threatening manner. The Black Panthers had exploited the statute in their home city of Oakland as a defensive measure against the mistreatment of Black residents by the nearly all-white police force, and the menacing spectacle of armed Black men patrolling the streets of a major city had so alarmed white Californians that the state

legislature had resolved to clamp down on the provision and wipe it off the books. That day in Sacramento, Bobby Seale, chairman of the Black Panther Party, delivered a statement to the press: "The Black Panther Party for Self-Defense calls upon the American people in general and the Black people in particular to take careful note of the racist California legislature which is considering legislation aimed at keeping Black people disarmed and powerless at the very same time that racist police agencies throughout the country are intensifying the terror, brutality, murder, and repression of Black people." Jump forward fifty years, change the color of everyone's skin, plug in the words "deep state" for "racist," and Seale's comments sound remarkably similar to the pro-gun pronouncements of white supremacist organizations today. In another flip between then and now, Ronald Reagan, the hard-right conservative governor of California at the time, emerged from his office after the Panthers had left the building and told reporters, "There's no reason why on the street today a citizen should be carrying loaded weapons" and that guns "are a ridiculous way to solve problems that have to be solved among people of good will."

It is important to remember the times. A month after the Black Panthers' visit to the capital, which the press was now calling the "Sacramento Invasion," the Six-Day War broke out in the Middle East, the fighting in Vietnam had reached new levels of ferocity as the American presence swelled to more than half a

million troops, and across the bay from Oakland, the flower children in San Francisco declared 1967 to be the Summer of Love. Elsewhere in the country, it was the Summer of Bloodshed, Fires, and Broken Glass, as impoverished Black communities in dozens of cities rose up in waves of spontaneous protest against their local governments and police forces, an explosion of pent-up grievances and frustrations that led to numerous gun deaths, thousands of injuries, tens of thousands of arrests, and widespread destruction of public and private property. Atlanta, Boston, Cincinnati, Buffalo, Tampa, Birmingham, Chicago, New York, Milwaukee, Minneapolis, Rochester, Toledo, Portland, and, worst of all, that is, deadliest of all, Detroit and Newark, where the devastation was so profound that neither city has fully recovered in the fifty-plus years since. In 1967, the population of Detroit was somewhere between 1.5 and 1.6 million. Today it is 670,000.

The upheavals continued through the early months of 1968, beginning with the Tet Offensive launched by the North Vietnamese and their allies in the South, a coordinated series of shock attacks by sapper commandos on more than one hundred South Vietnamese cities and towns, and even though the offensive was pushed back by American forces, more than half a million South Vietnamese civilians had been turned into homeless refugees and America's military strategy was in ruins, for the message was that the North Vietnamese would never give up, that they would go on

fighting until the last person in their country was dead, and that no matter how many additional American soldiers were thrown into battle, America could never win the war. On March thirty-first, President Johnson appeared on television and announced that he would not be running for reelection, an admission of failure and a mournful acknowledgement that public backing for the war had eroded to such a point that his policies had been rejected. Just four days after that, Martin Luther King was assassinated in Memphis, and all at once hundreds of thousands of people ran out into the streets and started smashing windows and burning buildings in more than one hundred cities across the country. America seemed to be on the verge of an apocalyptic breakdown, and yet as spring melted into summer, more was still to come. Two months and one day after Martin Luther King was shot and killed by a rifle, Robert Kennedy, in the minutes following his victory in the California presidential primary, was shot and killed by a handgun in Los Angeles. Put their ages together, and the thirty-nine-year-old King and the forty-two-year-old Kennedy had barely managed to live the life of one old man.

The California legislature had passed the gun control law that disarmed the Black Panthers in July 1967, and now, eleven months later, the United States Congress passed the Omnibus Crime Control and Safe Streets Act of 1968, followed by the Gun Control Act of 1968 in October, the first pieces of federal legislation pertaining

to firearms since the 1930s. Neither law had much bite to it, and each one proved to be largely ineffective, but if nothing else they represented some sort of national response to the national problem of growing gun violence, and the still apolitical NRA of the time backed the effort as something "the sportsmen of America can live with." So said Franklin Orth, the executive vice president of the organization, but, as Winkler observes in his book,

> Some rank-and-file members . . . were vigorously opposed to the new laws and were furious with Orth. This emerging group of internal critics was motivated less by opposition to the particulars of the new laws than by opposition to the very idea of gun control. Their attitude was reflected in the editorial pages of the specialized gun magazines of the day—*Guns and Ammo, Gun Week, Guns*—where anti-gun control screeds were fast becoming the norm. In the view of these nascent gun hard-liners, Orth and the current NRA leadership were focused too much on the sporting uses of guns and not enough on personal self-defense and the Second Amendment. In a time of rising crime rates, easy access to drugs, and the breakdown of the inner city, the NRA should be fighting to secure Americans the ability to defend themselves against criminals. The NRA, they thought, "needed to spend less time and energy on paper

targets and ducks and more time blasting away at gun control legislation." The faction even tried to have Orth fired. They failed, but the controversy over the gun control laws of the 1960s was, as one writer noted, "just the opening volley in what was to become an all-out war, one that would split the gun group wide open over the next decade."

What happened over that next decade was the transformation of the NRA into one of the most powerful lobbying groups in the country and its anointment as the principal spokesman for the rapidly expanding anti-gun-control movement, which has attracted tens of millions of adherents in the decades between then and now. In spite of the NRA's dubious financial practices and recent troubles with the law, the work it began in the seventies and eighties was so successful that with or without the organization to lead the charge, the movement is strong enough to carry on under its own steam. The irony is that a movement which is predominantly white, rural, and conservative should have come into being because it embraced the gun philosophy of a group which was Black, urban, and radical: the foundational belief that guns are primarily an instrument of self-defense and, to quote Chairman Mao (as the Panthers did), that "political power grows out of the barrel of a gun." The real or imagined danger posed by Bobby Seale, Huey Newton, and their followers was thwarted by the

efforts of the California state legislature and then squashed by the further efforts of J. Edgar Hoover's FBI through the clandestine operations of its COINTELPRO unit, which infiltrated the group with informers and *agents provocateurs* and, in conjunction with the Chicago police, resorted to out-and-out, unprovoked murder by shooting twenty-one-year-old Fred Hampton as he lay asleep in his bed at night. Nevertheless, the ideas espoused by the short-lived Black Panther Party reframed the issue of guns in such a persuasive manner that they took hold among their white coun-terparts at the other end of the political argument, and because the Black Panthers were few and the white conservatives were many, those ideas stuck—and are now accepted as one of the fundamental dogmas of American life for a large segment of the population.

A large segment, but by no means the largest, and with that one cold fact we plunge headfirst into the dark waters of the American chaos that surrounds us today.

This is a country that was born in violence but also born with a past, one hundred and eighty years of prehistory that were lived in a state of continual war with the inhabitants of the land we appropriated and continual acts of oppression against our enslaved minority—the two sins we carried into the Revolution and have not atoned for since. Like it or not, and regardless of all the good America has done over the course of its existence, we continue to

be burdened by the shame attached to those sins, those crimes against the principles we profess to believe in. The Germans have faced up to the barbarism and inhumanity of the Nazi regime, but Americans still hoist Confederate battle flags throughout the South and elsewhere and commemorate the Lost Cause with hundreds of statues glorifying the traitorous generals and politicians who ripped the Union apart and turned the United States into two countries. The argument for not tearing those monuments down is that they are part of our history. Imagine a German landscape cluttered with Nazi banners and statues of Adolf Hitler. "Look at that swastika," the proud German says to the bewildered American tourist. "It's part of our history!" In Berlin, there is a museum dedicated to the victims of the Holocaust. In Washington, there is no museum dedicated to the victims of slavery. Lest anyone think I am exaggerating when I make the connection, note that Hitler's policies about race were directly inspired by American segregation laws and the American eugenics movement. Mix them together, and the result is the Nuremberg Laws and an archipelago

* For a thorough examination of the interlocking connections among the eugenics movement, Confederate statues, and Hitler's race policies, see Siri Hustvedt's essay in *Literary Hub* (July 8, 2020): "Tear Them Down: Old Statues, Bad Science, and Ideas That Just Won't Die."

of death camps stretching from Germany into Poland that led to the extermination of millions.*

A birthright of violence, but also a country that has been split down the middle since its inception, not just between white and Black or settler and Indian but between white and white as well, for America is the first nation on earth to have been founded on the principles of capitalism, which is an economic system propelled by competition and therefore, necessarily, by conflict, for in the game to accumulate wealth and property—the only signs of power in a land without aristocrats or kings—there will be some who win and many who lose, and consequently each individual must rely solely on himself to brave the jungle of rat races, dog-eat-dog battles, and bull and bear markets, which fosters a deep-in-the-bone, often unconscious worldview in which the individual takes precedence over the group and selfishness triumphs over cooperation. Not for everyone, of course, and by no means in all places at all times, but for every example of the two dozen farmers who pulled together to build a neighbor's barn or the two hundred workers who banded together to unionize their shop, there is a countervailing example that demonstrates the lengths to which the fat cats have been willing to go in defense of their interests: the brutal suppression of dozens of strikes in the late nineteenth and early twentieth centuries, for example, as when Andrew Carnegie's business associate, Henry Clay Frick, called in a battalion of

armed Pinkerton agents to fire on workers at the Homestead Steel Works in Pennsylvania, or the systematic purge of pro-labor, anti-capitalist political groups during the 1919 Palmer Raids that led to massive arrests and deportations of *undesirables*, or, just recently, the extreme measures taken by Amazon to block the unionization of one of its shipping centers in Alabama. From the earliest days of the Republic, we have been divided between those who believe that democracy is a form of government that grants individuals the freedom to do whatever they please and those who believe that we live in a society and are responsible for one another, that the freedom given to us by democracy also comes with an obligation to help those who are too weak or too sick or too poor to help themselves—a centuries-long conflict between the need to protect individual rights and freedoms and the interests of the common good.

Nowhere is this conflict more intense than in the ongoing debate about guns, for the philosophical divide between the two camps is so profound that for many decades now it has prevented the gun-control and anti-gun-control forces from sitting down together to work out a compromise solution that would address the heartbreaking calamity of excess gun violence that continues to spread into every corner of the United States. The deadlock is bitter and often savage in its mutual animosity, so much so that in recent years the two sides have been driven so far apart that

one often feels that more than just opposing the other's position, each one is talking in an entirely different language. Meanwhile, one and a half million American lives have been destroyed by bullets since 1968—more deaths than the sum total of all the war deaths suffered by this country since the first shot was fired in the American Revolution.

A majority of Americans support the right of individuals to own guns, but that same majority is overwhelmingly in favor of enacting measures that would put a stop to the deadly violence caused by guns. The anti-gun-control minority argues that the problem is not caused by guns but by the people who use them. They are both right and wrong, just as they are both right and wrong when they argue that the phenomenon of mass shootings is a mental health issue, for the fact is that most mass shooters are mentally and emotionally disturbed, and most of them fantasized about shooting and killing large numbers of people long before they committed their crimes. The problem is that many other people also have fantasies about killing strangers or family members or friends or enemies and never do anything about it. No one can be punished for his or her thoughts, no matter how murderous or sadistic those thoughts might be, and therefore the law is powerless to intervene until after it is too late—when those murderous thoughts have been turned into deeds and the families of the dead are burying their sons and daughters in the ground.

The anti-gun-control minority is correct when they say that gun violence is caused by the irresponsible or unhinged people who use guns, but to say that guns do not cause gun violence is no less ludicrous than saying that cars do not cause car crashes or that cigarettes do not cause lung cancer. Not every person who drives a car will be in a crash, not every cigarette smoker will die of lung cancer, and not every gun owner will use his gun to maim or kill himself or someone else. But people shoot other people with guns because they have guns, and people commit suicide with guns because they have guns, and the more guns there are to be bought and the more people there are to buy them, the more people will kill themselves and others with guns. This is not a moral or political statement—it is a question of pure mathematics. Hand out boxes of matches to twenty young children at a birthday party, and there is every chance that the house will burn down before the party is over.

The majority wants to stop gun violence by making it more difficult to obtain guns. Strict enforcement of background checks, gun-purchase bans on people who have committed violent crimes, eliminating the no-check loophole for purchases at gun shows, and dozens of other sensible proposals to help mitigate the damage caused by guns have been put forward in Congress, but because of the Constitutional impediments that have ensured minority control of the Senate, it is all but certain that these bills

will be blocked by Republican filibusters. There are other measures that can be taken, however, ones that do not depend on the passage of new laws but on the vigorous enforcement of old laws, such as an all-out campaign by the Department of Justice to crack down on the illegal trafficking of guns as a criminal violation of interstate commerce laws, or a similar campaign by the Department of Homeland Security to delve into the operations of domestic terrorist groups, the heavily armed and ever more dangerous white supremacist organizations such as the crazed band from Michigan that hatched a plot to kidnap and murder the governor for issuing a temporary lockdown order on the state during the early months of the pandemic. Neither one of these actions would put an end to gun violence, but they would mark a small but important step in the right direction, and given how sharply divided we are on almost all things during this time of furious discord, to move a couple of inches forward is surely better than standing still.

Meanwhile, the fissures in American society are steadily growing into great chasms of empty space.

If Donald Trump had done an even moderately successful job of leading the country during the pandemic, he might not have lost the election in November 2020, but he didn't, and therefore he did, and once the final chapter of his presidency began, the lame-duck epilogue that stretched on for two and a

half months, all hell broke loose, and the country was battered in ways not seen since the birth of the Republic. Never before had a defeated presidential candidate challenged the results of an election as strenuously as this one did, and never before had a sitting president instigated a coup to take back the power he had lost. Astonishingly, but also predictably, there are millions who supported and continue to support his fraudulent claim that the election was stolen from him, and when a mob of those supporters invaded the Capitol on January sixth intent on lynching the vice president and murdering the congressional leaders of the Democratic Party, it was only by the grace of pure dumb luck that dozens of people were not slaughtered. America has entered a new, previously unimagined territory, and as I write these words today, seven months after Trump's departure from office, not one person anywhere between Maine and California, not anywhere between the northern edge of Minnesota and the southern tip of Florida, has the slightest clue about what will happen next.

Meanwhile, gun violence has risen sharply since the outbreak of the pandemic, saturating the American troposphere with a dense profusion of newly minted bullets. The recently published 2020 numbers show that homicides have increased by thirty percent over 2019 in nearly all of the three dozen largest cities in the country, and the statistics for the first half of 2021 are even more dire than those of 2020. In my own city of New

York, shootings have gone up by seventy-three percent from last May to this May, and the legal sales of guns are so strong that manufacturers can barely keep pace with the demand, even as black market trafficking in illegal guns continues to proliferate. According to the newest findings, gun ownership has soared from thirty-two percent of the population to nearly thirty-nine percent in the eighteen months since the pandemic began.

Meanwhile, George Floyd's murderer from the Minneapolis Police Department has been sent to prison for twenty-two years, largely thanks to the steady hand and clear eye of Darnella Frazier, a brave seventeen-year-old girl who filmed the entire eight and a half minutes of that cold-blooded, senseless killing for everyone in America and the rest of the world to see. The demonstrations following George Floyd's murder were the one sign of hope I felt for our collective well-being during the dark, early days of the pandemic, as large biracial crowds marched together in over two thousand towns and cities across the country, but whether those displays of Black-white unity mark a genuine shift in the American climate or nothing more than a temporary break in the clouds is not yet certain. Mostly, I think about the New York cops who were crashing their nightsticks down on the bodies of peaceful protesters in Manhattan as gangs of teenage looters ransacked stores in SoHo just twenty or thirty blocks to the south with no police anywhere in sight. And

when I am not thinking about New York, I am mostly thinking about the small city in Wisconsin where my grandmother shot and killed my grandfather one hundred and two years ago and how in that same Kenosha this past August, as a crowd of demonstrators was rallying in support of Jacob Blake, an unarmed Black man who had been left paralyzed after a white police officer fired seven bullets into his back, a seventeen-year-old boy arrived on the scene armed with a semi-automatic rifle and shot and killed two protesters and wounded another, premeditated crimes that the now-former president condoned as acts of "self-defense." Then I turn my thoughts back to the seventeen-year-old girl with her cellphone in Minneapolis and ask myself whether the future belongs to her or to the seventeen-year-old boy with the rifle in Kenosha or whether the world will still be the same world it is now and the future will belong to both of them.

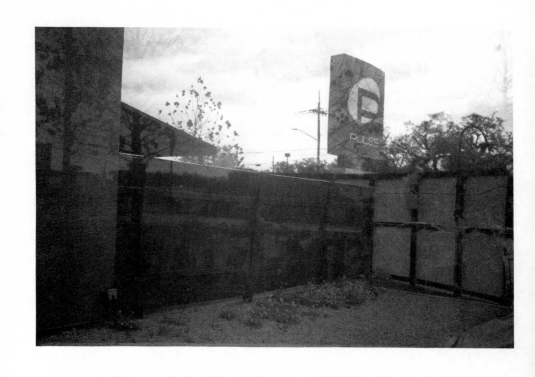

Pulse nightclub.
Orlando, Florida. June 12, 2016.
50 people killed; 58 injured (53 from gunfire, 5 in the ensuing chaos).
The nightclub has been closed since the day of the shooting.

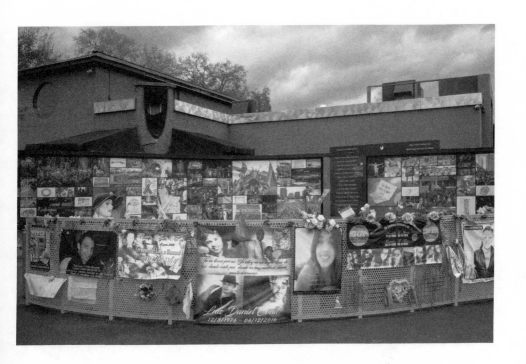

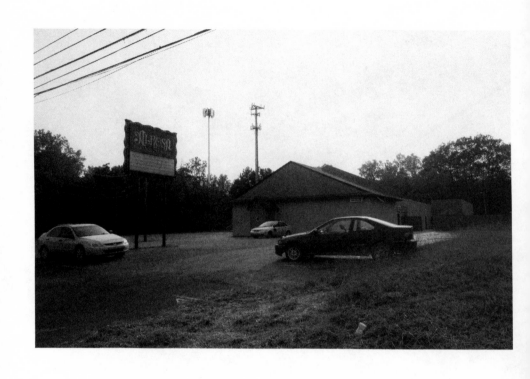

Alrosa Villa nightclub.
Columbus, Ohio. December 8, 2004.
5 people killed; 3 injured.

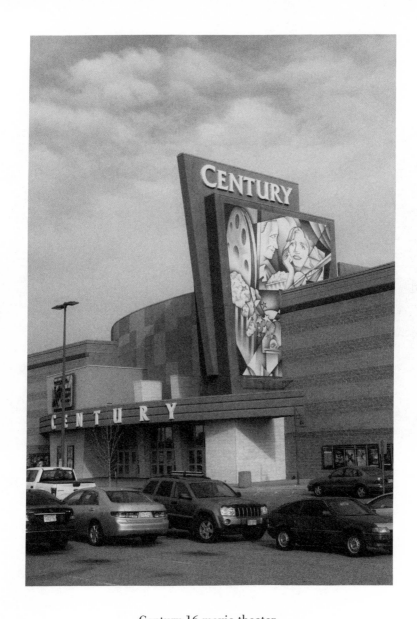

Century 16 movie theater.

Aurora, Colorado. July 20, 2012.

12 people killed; 70 injured (58 from gunfire, 4 from tear gas, 8 in the ensuing chaos).

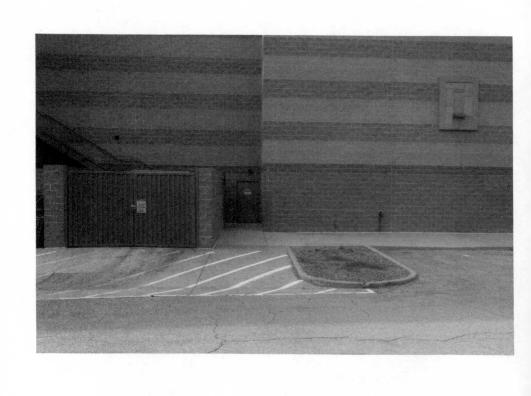

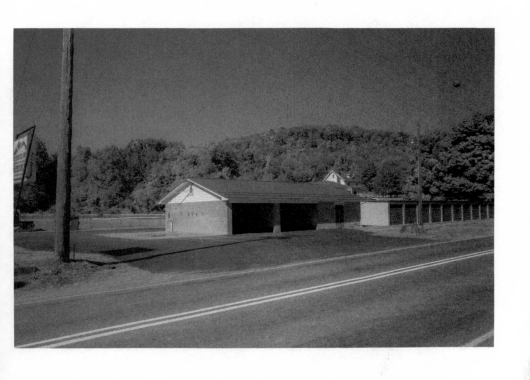

Ed's Car Wash.
Melcroft, Pennsylvania. January 28, 2018.
5 people killed; 1 injured.

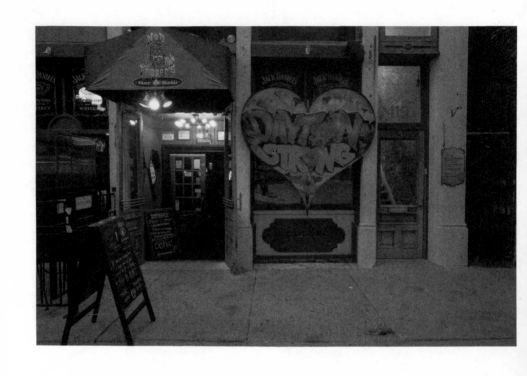

Ned Peppers Bar.
Dayton, Ohio. August 4, 2019.
10 people killed; 27 injured (17 from gunfire, 10 in the ensuing chaos).

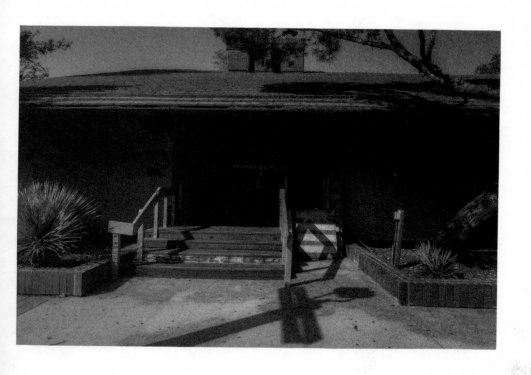

Borderline Bar and Grill.
Thousand Oaks, California. November 7, 2018.
13 people killed; 16 injured (1 from gunfire, 15 in the ensuing chaos).
The bar has been closed since the day of the shootings.

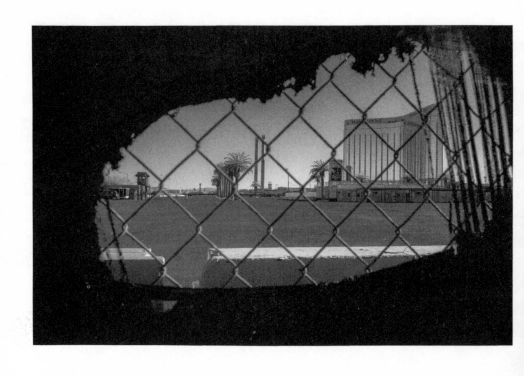

Mandalay Bay Hotel.
Paradise, Nevada. October 1, 2017.
61 people killed; 897 injured (441 from gunfire, 456 in the ensuing chaos).

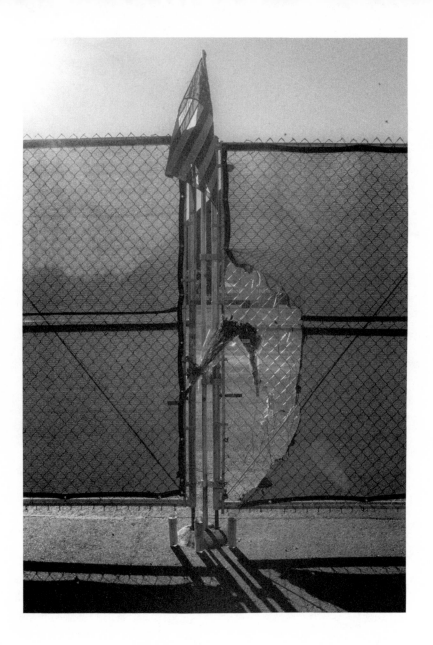